LIGHT
AND SHADE

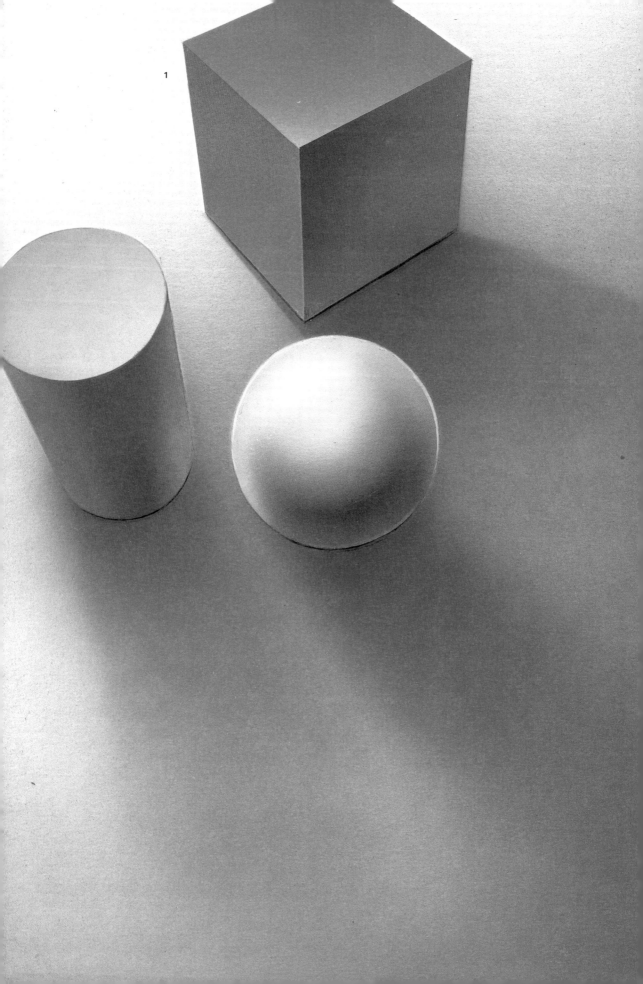

LIGHT AND SHADE

José M. Parramón

Light and shade in the history of painting.
Physical and psychological properties of light.
General principles.
The perspective and color of shade.
Contrast, atmosphere and the practical
study of the effects of light and shade.

Watson-Guptill Publications/New York

© Parramón Vilasaló, José M.
© 1991 Parramón Ediciones, S. A.

First published in 1991 in the United States by Watson-Guptill
Publications, a division of BPI Communications, Inc.,
1515 Broadway, New York, New York 10036.

Library of Congress Cataloging-in-Publication Data

Parramón, José María.
 [Luz y sombra en pintura. English]
 Light and shade / José M. Parramón.
 p. cm.—(Watson-Guptill artist's library)
 Translation of: Luz y sombra en pintura.
 ISBN: 0-8230-2769-4
 1. Shades and shadows—Technique. I. Title. II. Series.
 NC755.P3813 1991
 741.2—dc20 91-15654
 CIP

Manufactured in Spain

1 2 3 4 5 6 7 8 9 / 95 94 93 92 91

Contents

Introduction

Fig. 1. Still-life drawing class at a school of fine arts. The students are carefully observing the play of light and shade, value, and contrast, using plaster reproductions of classical statues as models.

"Before all else," said Leonardo da Vinci, "you must draw slowly and see what lights go to form the largest clear area, which are the darkest shadows, how they are combined and in what proportion." They would not let us paint until we had passed two exams with top marks, two years of drawing plaster.

Of course, once outside school, nobody took any notice of this "stupid" discipline. When we got home in the evening and every weekend, we all painted hands of flesh and blood, faces of flesh and blood. But I must admit that below the colors of the flesh we still saw the infinite range of shadow tones that we learned every day at that annex of the Fine Arts School.

This book contains a blend of these two attitudes: on the one hand, the "stupid" discipline of studying and practicing the effects of light and shade by means of plasters and tones, drawing and comparing values, drawing grays and gradations, capturing the effects of light and shade in lead pencil, blending black graphite with the fingers... "everything black and white, everything dead."

On the other hand, we will be reviewing the perspective of shadows, studying the colors of objects and the colors of their shadows, seeing the influence of color and of the effects of light on the forms of artistic expression, analyzing how artists in the valuist and colorist schools painted, and studying the techniques of color contrast and chromatic atmosphere. We will end by painting "flesh-colored hands and faces"—two pictures reproduced step by step, painted with valuist and colorist techniques. I hope that, just like the students at the annex of the Fine Arts School years ago, by the end of this book you will see below the flesh colors the infinite range of tones created by light and shadow. I also hope that the study of these two attitudes to painting will help you to paint better.

José M. Parramón

Now it is a warehouse for leather skins. Then, in the same yard of the same address in Calle Aribau, there was a well-known annex to the Barcelona School of Fine Arts. Every evening, from seven to nine, about sixty students, myself among them, would sit in front of long rows of easels and drawing boards to draw plaster sculptures.

White, cold, plaster sculptures. Plaster hands, plaster feet, plaster torsos, plaster statues of Venus, all drawn in charcoal, in charcoal pencil, or in lead pencil. All in black and white, all dead. But I must admit that those art teachers were partially right. Leonardo da Vinci was on their side when he said that first was form, then volume, and last was color.

On occasion, artistic treatment of the effects of light and shade has revolutionized the painting style of a period. The tenebrist style of Caravaggio, featuring strong contrasts between the lighted parts of a picture and those in shade, had a great influence on 17th-century artists: Velázquez, Ribera, Zurbarán, Rubens, Rembrandt, and so on. Rembrandt himself was one of the creators of another style whose main theme was the treatment of contrast: chiaroscuro, a way of seeing and painting light within shadow. (This effect can be seen powerfully reflected in the illustration on the next page, a detail of Rembrandt's *The Adulteress*, in the National Gallery, London). The Impressionists, in turn, transformed the colors on their palettes, creating a style in which light dominated the whole picture. Then came the Fauves, who painted model and background without shadows, in bright, flat colors, something the primitive artists of Egypt had done 2,500 years earlier, and which was also reflected in the style adopted by the artists of the Middle Ages in painting their Pantocrators (portrayals of Christ as judge and ruler). On the following pages, you can see and read about a brief history of the changes of style, form, and color in painting the effects of light and shade.

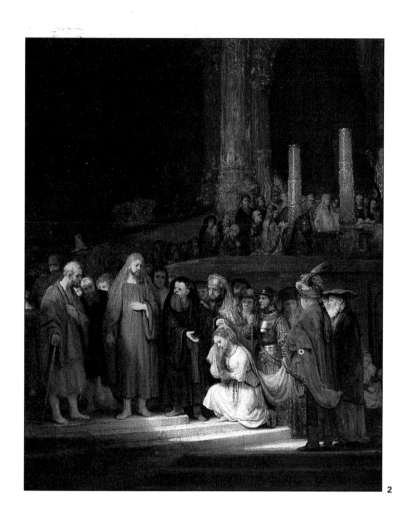

2

Light and Shade
in the History
of Painting

Light and Shade in Ancient Art and the Middle Ages

We see and appreciate form and color thanks to the effects of light and shade. We could assume, therefore, that artists have always been faithful to their vision of reality and have always tried to express the play of light and shade in their paintings, but the truth is that throughout long periods of history, painters preferred to ignore the effects of lighting and have represented figures and objects without relief, without volume, flat. This was the case with ancient Egyptian art (some 3,000 years ago): Although animals and plants were painted with a certain amount of relief, the main figures were always painted completely flat. In ancient Greece and Rome (some 2,000 years ago) figures were wholly naturalistic and were therefore given full volume, but in the Middle Ages painting became once more flat and polychromatic, highly decorative but without volume.

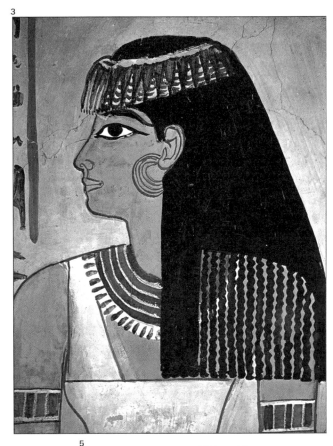

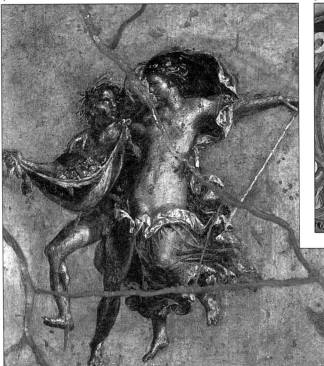

Fig. 4. *Venus and Dionysus*. Fresco in the Archaeological Museum, Naples. This fresco is from Pompeii and is therefore Roman, but its inspiration is clearly Greek, or Hellenic. The Greeks represented light and shade in a very naturalistic way and were much imitated by the Renaissance artists.

Fig. 5. *Pantocrator* (detail). Twelfth-century apse fresco from the Church of Saint Clemente, Tahull, Lérida, Spain. In the Catalonia Art Museum, Barcelona. The absence of naturalism, of light and shade, in this work is explained by its reference to an eternal, transcendent reality. Flat drawing and colors were the only resources the medieval artist brought to his work.

Fig. 2 (previous page). Rembrandt van Rijn, *The Adulteress* (detail). National Gallery, London.

Fig. 3. Portrait of Meryt-Amon. Tomb of Thebes, Egypt. The portraits of classical Egyptian art, in flat colors and with a total absence of modeling, express the power of the subject and a time-less permanence.

Light and Shade in Flemish Painting

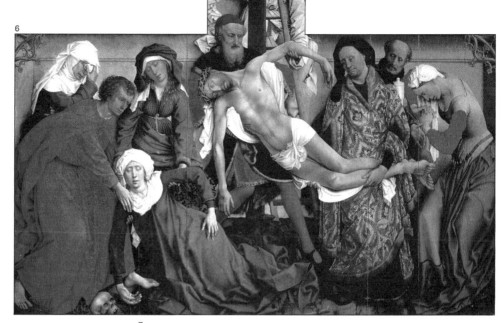

Fig. 6. Rogier van der Weyden, *Descent from the Cross*. Prado Museum, Madrid. This composition in the form of a frieze is strongly reminiscent of a bas-relief, because of the artist's treatment of the robes of the figures. The painter used side lighting to bring out the relief of the folds while always respecting the intensity of the colors, and without introducing exaggerated effects of light and shade.

Fig. 7. Jan van Eyck, *Arnolfini Marriage Group*. National Gallery, London. Thanks to the perfecting of the technique of oil painting, van Eyck was able to reflect the atmosphere and the light faithfully, without attenuating medieval intensity of color.

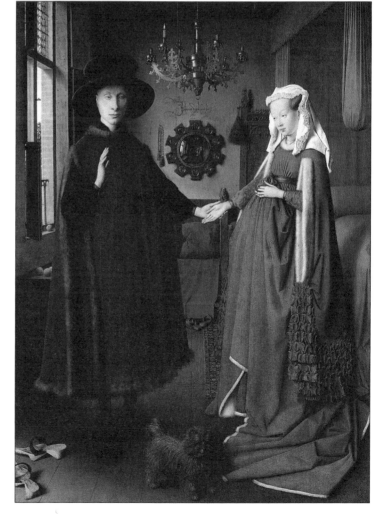

During the fifteenth century, Flanders, as what is now Belgium was then known, was the scene of the commencement of a superb pictorial art, a period of great innovation preceding the splendors of the Italian Renaissance. Such was the magnificence of this period that it is often known as the Northern Renaissance. The most outstanding figure of Flemish art was, without doubt, Jan van Eyck (1390-1441). This painter is attributed with no less than the invention of oil painting. Whether this is true or not, the subtle effects and complexity that he brought to the newly created technique were truly extraordinary.

Oil painting permitted the Flemish artists to represent the most subtle effects of light and shade with unequalled precision. The works of van Eyck, Rogier van der Weyden, Hugo van der Goes, or of the Master of Flémalle generally depict figures dressed in rich robes and bordered cloaks bathed in the soft light of the North. Each tiny detail, each fold, each surface of glass, wood, or wool is rendered with splendid precision and volume.

Light and Shade in the Renaissance

The enormous number of innovations in terms of style, techniques, and subject matter produced by the Italian Renaissance could fill hundreds of books, and the new treatment of light on objects is by no means the least important. It is similar to that of the artists of classical antiquity; artists of the Renaissance were obsessed with that period and tried to emulate its art. But Renaissance artists sought a more rigorous sense of naturalism, the mathematic arrangement of space according to laws of perspective in which figures (idealized according to the classical canons) could move as we ourselves move through real space. To artists of those times had to study in depth the effects of light. Leonardo da Vinci (1452-1519) found a solution whereby he blended the outlines of his figures into the background to give expression to the effects of the light, so that the lighted areas appear clear and precise while the areas in shadow are blurred and diluted, losing precision of form. This procedure is known as *sfumato*, from the Italian for evaporating like a mist. The result is at the same time realistic and pictorial, highly artistic.

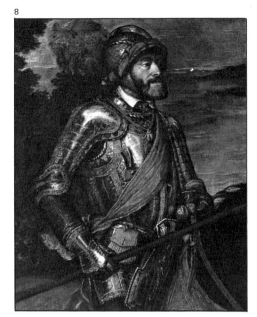

Fig. 8. Titian, *Equestrian Portrait of Charles V* (detail). Prado Museum, Madrid. Titian was the greatest Venetian painter of the Renaissance, a genius in his use of color. His are not the varnished colors of medieval art, but colors that produce a luminous atmosphere around the objects. In his pictures, the light makes surfaces shine and enriches the drapery and features of his figures with a variety of tones.

Fig. 9. Leonardo da Vinci, *Saint Anne with the Madonna and Child*. Uffizi Gallery, Florence. Leonardo invented a new representational technique that was to be much imitated later on: "sfumato," the blending into the background of contours in shadow. Using this technique, the artist can submerge figures into a dense atmosphere, a crepuscular light in which clarity of contour fades and the whole is enclosed in shadowy illumination, without abrupt contrasts.

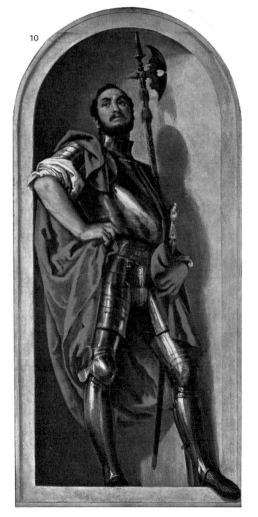

Fig. 10. Paolo Veronese, *San Menna*. Estense Gallery, Modena, Italy. A frequent device of Renaissance art was to paint a figure in a niche as if it were a sculpture. But there is nothing of stone about the figures Veronese painted; they are real, and the action of the light on them brings out their relief strongly, making them stand out from the niche, as in this example. The spirit of the Renaissance led artists to study carefully the action of light on the figure.

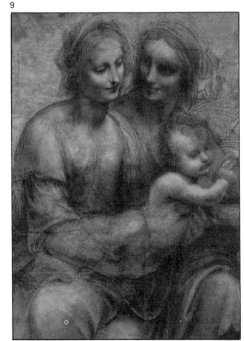

The Tenebrism of Caravaggio

The Renaissance tendency to "submerge" subjects in light and atmosphere, to surround them in a naturalistic background, toward the end of the sixteenth century and led to the baroque movement of the seventeenth century known as tenebrism, increased "the art of darkness." This sounds rather phantasmagoric, and works produced in this style often had fantastic qualities: The contrast of light and shade is violent, as if the objects or figures were enclosed in a room in complete darkness and were then suddenly submitted to the lateral lighting of candles. The effect is highly dramatic, ideal for the expression of religious mysteries. The inventor of tenebrism was Caravaggio, as imitated as Leonardo had been before him. Among the most important tenebrist painters were the Spanisards Ribera, Zurbarán and the French De La Tour.

Fig. 11. Michelangelo da Caravaggio, *The Calling of St. Matthew*. St. Luigi dei Francesi's Church, Rome. Caravaggio's revolutionary tenebrist technique gave maximum expression to light and shade contrasts.

Fig. 12. Georges De La Tour, *St. Joseph as Carpenter*. Louvre Museum, Paris. The tenebrism of this great painter, has a strongly intimate quality.

11

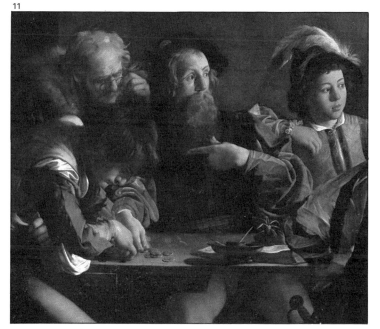

12

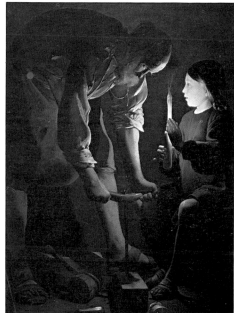

13

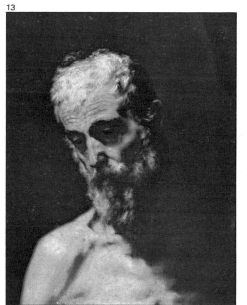

14

Fig. 13. José de Ribera, *Saint Andrew the Apostle* (detail). Prado Museum, Madrid. Ribera used rather crude tenebrism in some areas of this painting, but it is carefully softened in his rendering of surfaces, the hair, the wrinkles on the skin, and so on.

Fig. 14. Francisco de Zurbarán, *Still Life*. Prado Museum, Madrid. Zurbarán was the painter of monastery life, of humble objects dignified and spiritualized through the effects of light and shade.

Mannerism and Chiaroscuro

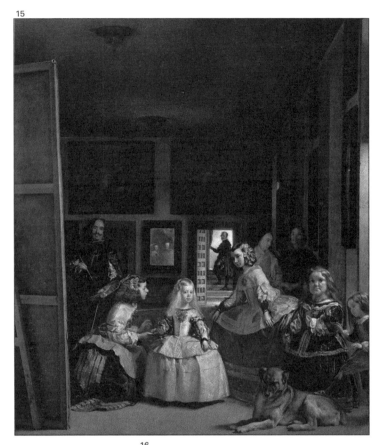

The tendency that began with Caravaggio at the end of the sixteenth century extended throughout Europe and was adopted to a greater or lesser extent by all the masters of baroque art: chiaroscuro, the composition of a picture using large areas of light and shadow. The early paintings of Velázquez (1599-1660), for instance, strongly feature tenebrist naturalism, which evolves toward a lighter technique closer to Impressionism, though always keeping within the canons of the tenebrist school. Rubens (1577-1640) used chiaroscuro to express the agitated sensuality of his volumes. But the most original of the baroque painters was the Dutchman Rembrandt (1606-1669). The transition from light to shadow in his work is gentle; the light is thick, golden and possesses a corporeality which, instead of lighting, appears to "drench" his subjects.

Each of these painters adapted the chiaroscuro technique to the requirements of his own sensitivity with outstanding results.

Fig. 15. Diego de Velázquez, *Las Meninas*. Prado Museum, Madrid. This is one of the most admired paintings in the history of art, a highly complex work full of masterful details, including incredibly natural light effects.

Fig. 16. Peter Paul Rubens, *Triptych of the Ascension from the Cross*. Cathedral of Notre-Dame, Amberes. Rubens was a consummate master in the expression of the volume of figures, whose muscles appear and disappear in the lighting with its chiaroscuro effects. He is the most representative example of baroque energy. In his work, light and shade are distributed over the canvas according to rich, syncopated rhythms.

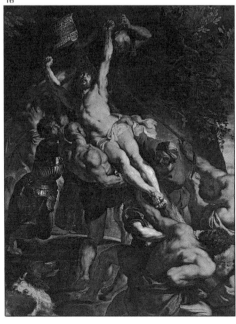

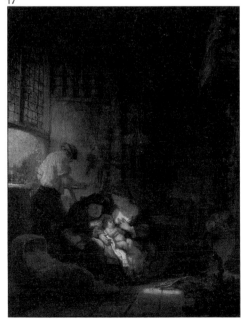

Fig. 17. Rembrandt van Rijn, *The Holy Family*. Paris, Louvre Museum. Rembrandt's light has a very rich quality and, we could almost say, texture in the golden ripe wheat color.

Light and Shade in Romantic Art

Two opposing tendencies lived side by side at the beginning of the 19th century: somber, ordered Neoclassicism and turbulent, fantastic Romanticism. Neoclassicism, with David and his disciple Ingres to the fore, rendered homage to the stylised art of Classic times, while the Romantics, of whom Goya was a forerunner and whose principal exponent was Delacroix, took a violent and imaginative stand toward art, accepting no rules. Clear, diffused light against unbridled use of chiaroscuro techniques.

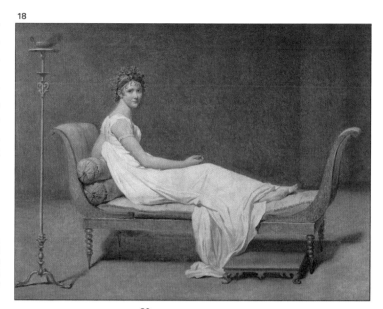

Fig. 18. Jacques-Louis David, *Madame Récamier*. Louvre Museum, Paris. The ideals of classical culture are defended in the work of Neo- classicists like David, who not only adopted a classical style but also painted motifs that seem to portray the life of Imperial Rome.

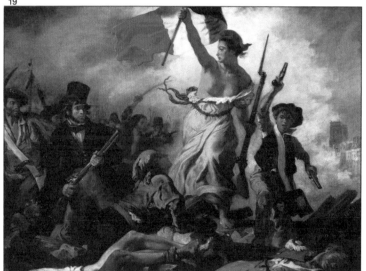

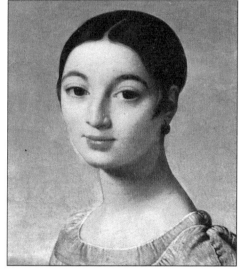

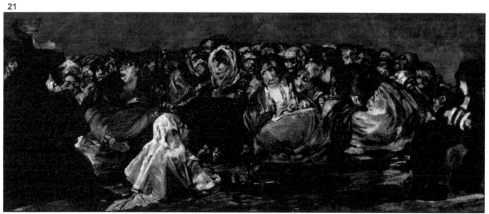

Fig. 19. Eugène Delacroix, *Liberty Guiding the People*. Louvre Museum, Paris. The French Revolution, is given appropriately frenetic treatment.

Fig. 20. Jean-Auguste-Dominique Ingres, *Portrait of Mademoiselle Rivière* (detail). Louvre Museum, Paris. There are no abrupt shadows or chiaroscuro effects.

Fig. 21. Francisco de Goya, *The Black Paintings* from the Quinta del Sordo. Prado Museum, Madrid.

The Treatment of Light in Impressionist Art

The advent of Impressionism revolutionized the world of painting. As we have seen, the Renaissance painters had adopted the formula of darkening the colors of shadows to create a greater sense of reality. During the nineteenth century, this formula came to be regarded as too conventional by a new group of young painters who wanted to express the truth of nature without following academic dogma. A few isolated painters, such as Turner in England, had already begun to take this new path, but it was not until the middle of the century when artists like Monet, Pissarro, Renoir, and Cézanne left their studios to paint outdoors, finding that "en plein

22

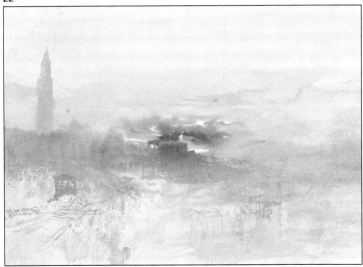

23

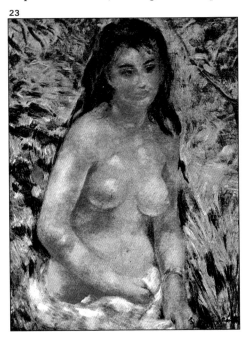

24

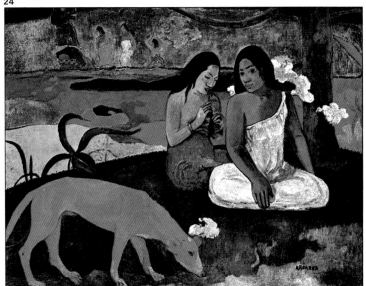

air," shadows can be light and full of colors and that each object in the landscape is made up of a multitude of tones produced by the reflections of other objects. This was not understood by the critics, one of whom said of a nude by Renoir, "The torso of a woman is not a pile of meat . . . with greeny-violet stains like a putrefying cadaver." The Impressionists suffered many attacks of this nature, but in the end their fresh, rich vision of light won acceptance. At the end of the nineteenth century, taking

their inspiration from the Impressionists, artists such as Gauguin returned to the clear, lively colors that had been abandoned for so long.

Fig. 22. J.M.W. Turner, *St. Giorgio Maggiore.* British Museum, London. Turner was a true forerunner of the Impressionists. His vision of landscapes—dominated by highlights, reflections, and the luminous effects of sunlight—places him more than twenty years ahead of his time.

Fig. 23. Pierre-Auguste Renoir, *Nude Girl in Sunlight.* Louvre Museum, Paris. This wonderful painting illustrates the revolution brought about by Impressionism. Sunlight is captured in all its richness through light touches of the brush,

which render the incredible diverstiy of hues of the flesh. Light and shade no longer mean clear and dark, but the contrast of vivid colors.

Fig. 24. Paul Gauguin, *Arearea.* Orsay Museum, Paris. Gauguin went to Polynesia in search of a primitive, pure art, but he had already learned the Impressionist lessons before he began to use color in all its purity. He did not want to imitate the effect of the light, but to evoke it through the use of strong contrasts.

Light and Shade in Modern Painting

The conquests of the Impressionists gave artists a new-found freedom over the rendering of light and color. A Post-impressionist painter, Maurice Denis, declared at the end of the nineteenth century that "a picture, rather than a landscape or a battle, is essentially a flat surface covered with colors assembled in a certain order." From this moment on, the watchword of painters was "total liberty in the rendering of color and form, of lights and of shadows."

At the beginning of the twentieth century, the Fauve (fauve means wild beast) painter Vlaminck applied color violently, creating intense contrasts evoking a crude, dazzling light. Vlaminck was an expressionist, a lover of strong, primitive sensations.

In 1907, Pablo Picasso invented cubism. What the Fauves had done with color, the cubists did with form. Objects are broken down into surfaces and extended to cover the whole area of the canvas. Braque painted pictures composed of flat surfaces resembling scales, with a light that is no longer the light of nature but a fantastic kaleidoscope. The same is true of Duchamp, whose figures recall robots made of metal sheet engaged in frenetic, clattering movements.

Painting in this century has become a creation independent of nature, following its own laws and inventing its own lights and shadows.

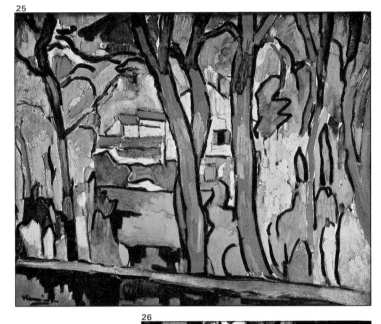

Fig. 25. Maurice de Vlaminck, *Landscape with Red Trees*. Pompidou Centre, Paris. Vlaminck was a fauve painter, concerned with the expressive intensity of strong colors. In this style of painting, color becomes independent of reality, and light is suggested through these violent contrasts.

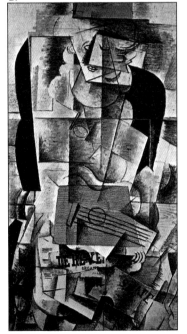

Fig. 26. Marcel Duchamp, *Nude Descending a Staircase*. Philadelphia Museum. In this picture, the volume of the figure is reduced to planes of color that overlap to suggest movement.

Fig. 27. Georges Braque, *Girl with Guitar*. Modern Art Museum, Paris. Braque's cubism involves here the use of papers painted and glued to the canvas, in a way evoking traditional pictorial lighting.

In this chapter we will talk about the general principles of light and shadow: the physical and psychological features of light; types of light; real and projected shadows; factors affecting the shape of shadows; reflected light; and the direction, quantity, and quality of light. For instance, a model or subject lit frontally appears flat, devoid of the effects of light and shade, because frontal lighting practically eliminates volume. In consequence the shape of objects is distinguished through their color. This fact was used by the Postimpressionists and even more by the Fauves to paint without the effects of light and shade, rendering the form of objects through flat colors. You may already have known all this, but it is still worthwhile to summarize it with other facts about light and shadow, as we shall do on the following pages.

General Principles

The Physical and Psychological Aspects of Light

There are two basic general aspects of light regarding the model and lighting. These are the physical aspects and the psychological aspects.

In its physical aspect, light permits us to perceive the form and size of objects.

In its psychological aspect, light is an invaluable means of expression.

The light that a model receives tells us whether it is made up of flat forms or whether these are curved, spherical, concave, and so on. Light reveals all the physical characteristics of the model to us, showing us its dimensions and proportions through comparison with other objects.

Moreover, depending on whether the lighting of the model is harsh, strong, bright, soft, monotonous, or cold—in combination with other factors—the model can express happiness, sadness, unease, peace, and other moods.

Physical Aspects of Light

Types of Light
There are two types, or sources, of light that we can use for drawing or painting, which are:

1. *Natural light sources:*
The sun, the moon.

2. *Artificial light sources:*
Electric lighting, gas lighting, candlelight, and so on.

These light sources can be used separately or in combinations. In the latter case we say that the model is lighted by a basic light and by another complementary source. For example, we place the model next to a window, where it receives sunlight directly (basic light), and then soften the parts in shadow with the help of a reflecting screen or an electric light (complementary source).

29

30

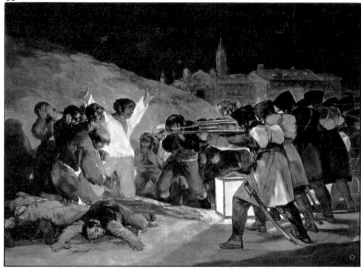

31

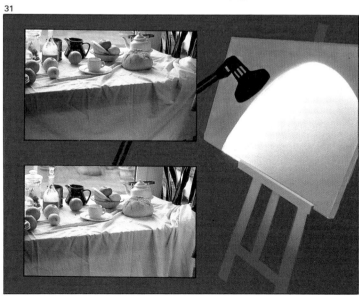

Fig. 29. Lighting can be used to enhance the physical qualities of objects.

Fig. 30. Goya, *Executions on May Third*. Prado Museum, Madrid. This famous painting is an example of lighting used as an element of expression.

Fig. 31. Complementary lighting can easily be obtained with a reflecting screen.

Light, Shade, and the Form of the Cast Shadow

Light and Shade

When we light the model, it appears darkest on the side opposite the light source. At the same time, the lighted object projects a shadow over the surface on which it has been placed. This shape of this second shadow can be altered by changing the contour of the surface or surfaces next to the lighted object. (See Fig. 32).

The first of these shadows is known as the **real shadow**.

The second, projected onto the flat surface, is known as the **cast shadow**.

A cast shadow reproduces the outline of the object being lighted. Generally speaking, this shadow is not an exact duplicate of the silhouette of the model, but appears deformed in its width and length, among other reasons because of the position of the light source in respect to the lighted body.

Let us consider this fact for a moment. It is important for us to understand it and always bear it in mind when we are drawing or painting outdoors, even more so when we are drawing from memory and without an exact reference to the model. The shadows made by the sun move, following the movement of the earth around the sun. So you could begin painting a landscape at noon with the sun directly overhead, and finish at five o'clock, with the sun much lower in the

sky. Needless to say, the shape of the shadows will have changed during the course of these five hours.

When the light source is directly above the model, the cast shadow is short and small, but with the light source to one side of it the shadow will be much longer. Imagine a tree lighted by the sun at midday, and the same tree at dusk, when the sun has almost completely disappeared over the horizon (Figs. 33 and 34).

Fig. 32. Here we can see the *real shadows*, those produced on the objects themselves, and the *cast shadows*, those produced on the surface on which the objects stand and the vertical surface behind them.

Figs. 33 and 34. The position of the source of light has an effect on the shape of the shadow, especially the cast shadow. The sun at midday concentrates the shadow under the tree, but at dawn or dusk the shadow is much longer.

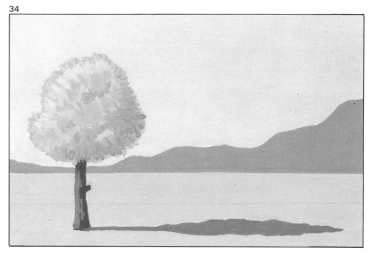

Other Factors Affecting the Shape of the Cast Shadow

Type of Light

In theory, the light of the sun and that of an electric light are transmitted in the same way: in straight lines, radiating outward from their source. But natural light reaches us from an immensely greater distance than artificial light. The sun is millions of miles away, while an electric light can be placed just a few yards from the model.

This being the case, looking at the facts from a practical point of view, we can say that:

1. Natural light is transmitted in *parallel lines*
(Figure 35)

2. Artificial light is transmitted *radially*.
(Figure 36)

Because of this, the shape of a projected shadow will be different depending on whether it is cast by natural or artificial lighting.

Point of View

Our point of view of the model implies that the shape of the shadow is affected by perspective, known as "the perspective of shadows."

At the bottom of the page you can see the same scene drawn from different points of view. In the first, taken from a point of view above the model, we see the shadows almost flat, and these are not affected by foreshortening (Fig. 37). In the second, as we come closer to the plane on which the model is positioned, the shadows become smaller, tending to become one single line, because of the effects of foreshortening (Fig. 38).

Figs. 35 and 36. The form of shadows depends on the type of light: natural, which extends in parallel rays, or artificial, which spreads in a radial direction.

Figs. 37 and 38. Point of view is another factor with an effect on the shape of the shadow. In these illustrations, we see the same model with the same lighting, but our perception of its shadow changes radically according to the position from which we look at it.

35
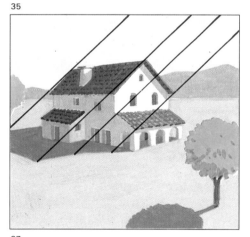

36
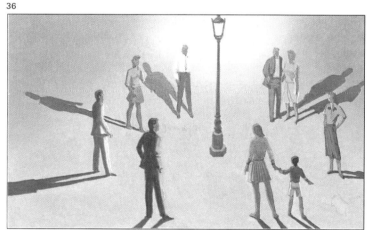

37

38

Reflected Light

You are at home and are planning to paint a portrait from life. The model is a friend willing to pose for you. And you have already decided where you want your model to sit. "Go over there, by the window," you say. And you have already planned to have a dark background, and you have imagined that, with her brown hair and white blouse—you have asked her to wear a white blouse, of course—her figure will stand out splendidly against the dark background and that your portrait will come out "just great," as you said to her.

She is happy. And then you realize that it does not work, that with frontal lighting a little to one side, the right-hand side of the figure (her left) is too dark and gets lost in the background. Neither the model's facial profile nor shoulder nor arm can be clearly seen in the side in shadow, and her hair can barely be made out (Fig. 39).

But you are a resourceful artist. You have seen how photographers eliminate shadows by using screens or white surfaces, so you quickly search out a framed canvas from your studio (in fact, any white surface would do) and you place it on the shaded side, next to your model.

In this way, an extra light appears where the shadows end. *Reflected light* is visible in Figure 40. And so, happily, you begin to paint.

Reflected light helps us to perceive the form of objects, strengthening volume. It exists in all real shadows, but is stronger when there is a lot of light—outdoors, for instance—or in well-lighted areas.

Later on in this book, we will come back to this idea of painting or drawing with the help of a reflecting screen, and we will speak of the importance of basic light in its role of main lighting of a model. This leading role, by the way, should never be diminished or contested by complementary lighting.

Figs. 39 and 40. Reflected light is complementary light that indirectly illuminates those parts of the model that are in shadow. A little reflected light exists practically anywhere, but the artist can create it with a reflecting screen such as that used in Fig. 40. Notice how much this changes the appearance of the model's face.

39

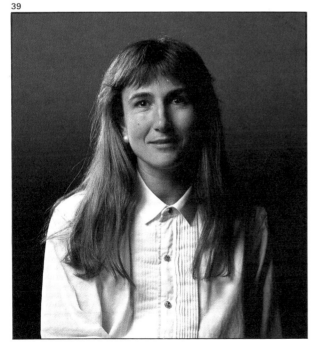

40

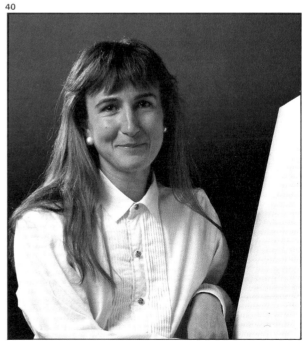

Psychological Aspects of Light

We mentioned earlier, as you will remember, that the psychological features of light provide the artist with an invaluable element of expression. Let us look now at the psychological principles of light, first taking the three factors that allow us to express ourselves through light:

a) **Direction of light**
b) **Quantity of light**
c) **Quality of light**

The expert artist uses these factors to render the form of things, imbuing them with the message of the work, and also to compose the work, distributing areas of light and shade to form a harmonious and aesthetically pleasing whole.
To understand and develop these possibilities, let us now study them one at a time, beginning with:

Direction of Light

Light can shine on the model from above, from below, from the side, from the front, or from the back. Each of these lighting directions has a technical name, and each expresses volume in a different way.

Front lighting: Light shines on the model from the front, so that shadows are practically hidden behind it. There is little volume or sense of depth. Objects stand out basically through their colors (Fig. 41).

Lateral front lighting: Light shines on the model from an angle of approximately 45 degrees, creating an excellent sensation of volume and depth. This is the most frequently used to reveal a model's form, appearance, and physiognomy (Fig. 42).

Fig. 41. Frontal lighting: There are practically no shadows on the model. This type of lighting is ideal for bringing out color.

Fig. 42. Lateral front lighting: Here you see the classic type of lighting for highlighting volume and clarifying form. This is a documentary type of lighting.

41

42

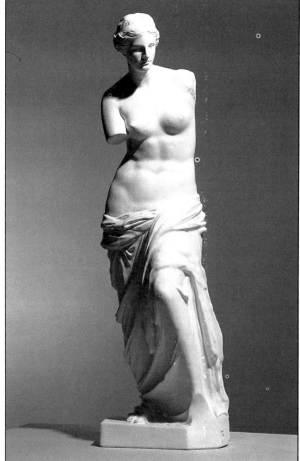

Side lighting: Light shines on the model from one side, leaving the other side in shadow. Volume and depth are given by the cast shadows. It should be noted that this is not a frequently used form of lighting (Fig. 43).

Semi-backlighting and backlighting: In both cases, light shines on the model from behind, leaving the parts seen by the artist in shade. The contours of the model have a characteristic halo of light. Volume is diminished by backlighting, but not depth, for this is accentuated through the effect of interposing atmosphere, more apparent here than in other types of lighting (Fig. 44)

Lighting from above: This form of lighting produces longer real shadows, which increase volume while decreasing clarity of features. This type of lighting is not frequently used (Fig. 45, on the next page).

Lighting from below: This form of lighting also produces longer shadows, which go up, producing fantastic, unreal volumes. This form of lighting is used only when very special effects are required (Fig. 46, on the next page).

Fig. 43. Side lighting: The technique of illuminating the model from one side reveals form, highlighting volume to dramatic effect.

Fig. 44. Semi-back-lighting and backlighting: Lighting the model from behind creates a halo of light that brings out the profile. Backlighting generally needs to be complemented by softer frontal lighting in order to soften contrast.

43

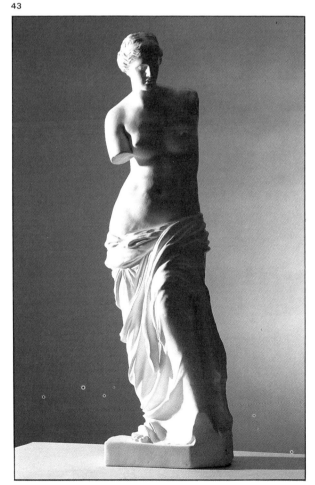

44

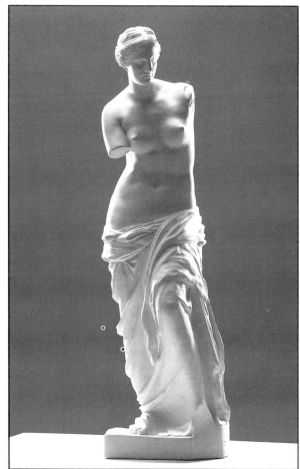

Direction and Quantity of Light

Direction of Light and Modeling

Modeling is achieving the illusion of the third dimension through certain resources of lighting, contrast, color, and perspective.

We say of particular images that they are well modeled when the combination of these resources gives the result of a perfect comprehension of the volume of the form, the distance between objects, and so on.

Naturally, the direction of the light is a decisive factor in the achievement of this effect. The artist must analyze the most appropriate direction of lighting in order to achieve the best possible modeling. But there is also another important factor that influences the message the artist wishes to transmit in a picture:

Quantity of Light

Weak light, a lot of light, medium . . . In each case the modeling of the subject has different characteristics, and each offers different possibilities regarding the message transmitted in the work.

For example, weak lighting entails the absence of reflected light and the formation of dark, almost impenetrable shadows. On the other hand, too much light can even diminish volume, which is deformed by highlights and reflections almost as strong as the light itself.

In any case, the quantity of light affects the *contrast* of the image, at the same time altering the *chiaroscuro*.

Contrast is the effect achieved through comparing two different values. Varying degrees of contrast can be achieved through different combinations of light, medium, and dark values, includ-

Fig. 45. Lighting from above the model: Lighting from directly above is rarely used because it lengthens shadows. However, positioning a diffused source of light above and at an angle of 45 degrees produces the classical zenithal lighting used by studio artists.

Fig. 46. Lighting from below the model: This is used in exceptional cases to express certain ideas or feelings, usually of a dramatic nature.

45

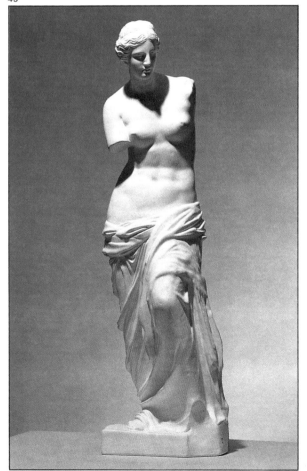

46

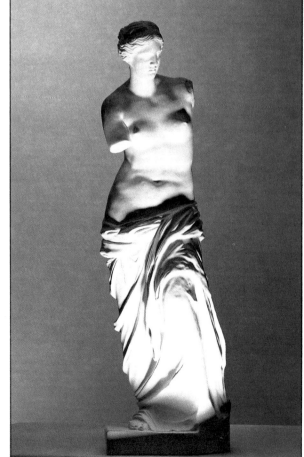

ing many subtle tonalities in between. Chiaroscuro means the combination of light and darkness. It is the art of "making light felt" all over the picture, even in the darkest areas, taking into account the distances between figures or objects (Fig. 47). The technique of chiaroscuro can be summed up by the following statement, made by the Italian artist J. Ronchetti:

> **"Shadows are never completely devoid of light."**

Both aspects, contrast and chiaroscuro, of which we will speak further later on in this book, are directly related to and depend to a large extent on the third factor we can express through light: quality of light.

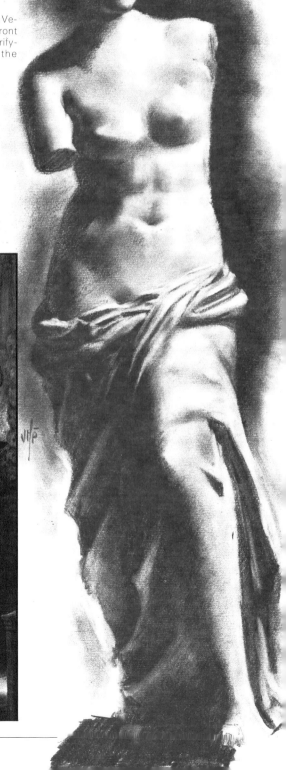

Fig. 47. Rembrandt, *The Adulteress* (detail). National Gallery, London. This painting is a classic example of light in shade, the chiaroscuro effect invented by this famous master.

Fig. 48. To draw this Venus, I chose lateral front lighting, ideal for clarifying the form of the model.

Quality of Light

Quality of Light

By quality of light we mean the variations in contrast, chiaroscuro, value, and so on that we see in the model, according to whether lighting is soft or hard, weak or strong. In order to understand these variations better, we need to distinguish between two types of lighting: *direct lighting* and *diffused lighting*.

Direct Lighting

The light of an ordinary light bulb in a spotlight or on a screen, concentrating its rays on the model, is a typical example of direct lighting.

Its main quality is that of causing a vivid contrast. This type of lighting forms strong shadows along with bright highlights that reflect back the light received with powerful effects. The message of the work will therefore be dramatic, suggesting deep passions or tragically sublime feelings.

This type of lighting includes all artificial lights, with the exception of fluorescent lighting. When natural lighting reaches the model through a small window, it also has the features of direct lighting: strong contrast and almost complete absence of chiaroscuro. An example of this is when a model is lighted by the sun's rays coming through a window into a large room in which the reflection from the walls is not strong enough to soften the strong contrast between the areas in shade and those in the light.

Figs. 49 and 50. Direct lighting, with an artificial light or sunlight shining straight onto the model, produces hard shadows that contrast with the light and can cause interesting effects in the drawing or painting of certain themes.

49

50

Diffused Lighting

Think of the way a landscape is lighted when the sky is cloudy. The light reaching the objects is softened, uniform, without vivid contrasts. This is called *diffused lighting*.

The principal feature of diffused lighting comes from the gentle transition between the parts in the light and those in shade. The shadows of the model may be intense or weak according to the quantity of light reaching it, but they always have a soft overall effect. The lighted areas, too, are without the vividness of direct lighting, and the effect is of greater harmony, a more normal type of contrast.

This type of lighting includes natural light on a cloudy day or with the sun half-hidden by clouds, the light of a clear day coming in through a window into which the sun does not shine directly (indirect sunlight, we could call this), indirect artificial light, fluorescent lighting, and any light source that takes on a diffused quality being toned down.

Figs. 51 and 52. Diffused light coming through a window or sunlight on a cloudy day produces zenithal lighting, a soft type of illumination with almost total absence of contrast. This is excellent for painting still lifes and figures in the studio, or certain outdoor themes (on rainy days, for instance).

51

52

The well-known rule that Ingres gave to his pupils, *"You paint as you draw,"* could indeed have been used as the title of this chapter. For in this chapter we are going to discuss a number of teachings about drawing highlights and shadows, about modeling and valuing and other techniques in order to improve our painting ability. We will discuss the framing and structure of various basic shapes, and we will look at how to draw a robe or piece of cloth, all through drawing with a lead pencil. We will give form and volume to these subjects, studying shading and gradation in general. Finally, we will look at the methods and rules for achieving a range of tones such as that in our model, practicing blending with our fingers and with paper stumps. You could say that we are going to put into practice the "stupid" discipline of learning to draw before beginning to paint.

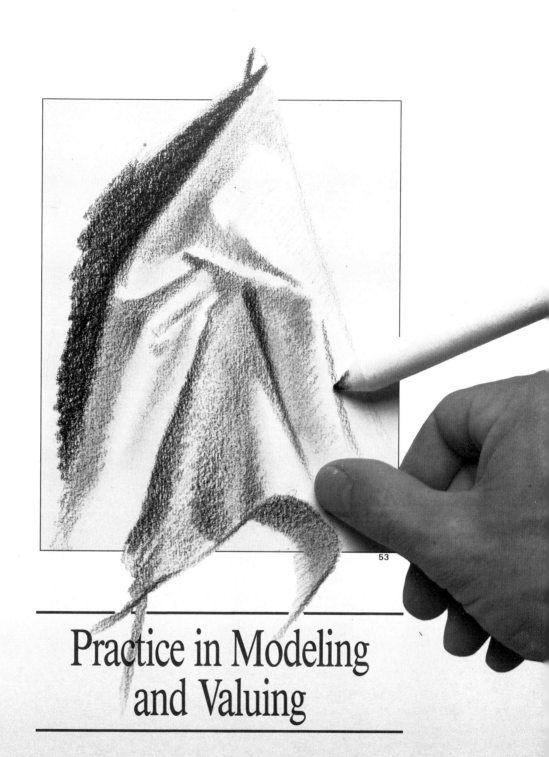

Practice in Modeling and Valuing

Values

When you are able to calculate and draw the proportions and dimensions of a model exactly, at the same time reproducing accurately the infinite range of tones making up the form, then you can say that you really know how to draw.

I would not say that the first is easier, but at least it is simpler to evaluate your success. On the other hand, it is more difficult to notice mistakes in your rendering of light and shade. The layman will hardly dare to give an opinion about the contrast, chiaroscuro, shade, highlights, and reflection in a drawing. The same person will, however, be able to appreciate the artistic worth of a piece when all these factors have been successfully applied. For volume, sense of depth, likeness itself, and everything in art depend on the rendering of light and shade.

The professional artist knows how to draw the correct intensity of each tone, get the relations between tones just right, and pay special attention to overall tone balance. This has a name in our profession:

Valuing

Values are tones, and different tonalities have different intensities. Remember this definition. Read it again, and then we will move on from theory to practice, using an ordinary cube and a cardboard cylinder that you can easily make for yourself.

In Figure 54 on this page, you can see a scale diagram of the forms and sizes required to make a cube and a cylinder. Use rather thick white paper or light cardboard, noting that the circle of one of the faces of the cylinder is missing. This you can make by cutting out the circular piece marked "CYLINDER."

Let us suppose that you have made your cube and cylinder. Now place them in front of you, on your work table, lighting them with a lamp, as in Figure 55 on the following page. Have you done that? Now put the cylinder to one side for a moment, because we are going to work at first with only the cube.

Fig. 54. Models from which to make a cube and a cylinder from white cardboard. The measurements are noted in the diagram. You just need to fold the figure on the broken lines and then to glue the flanges marked A.

54

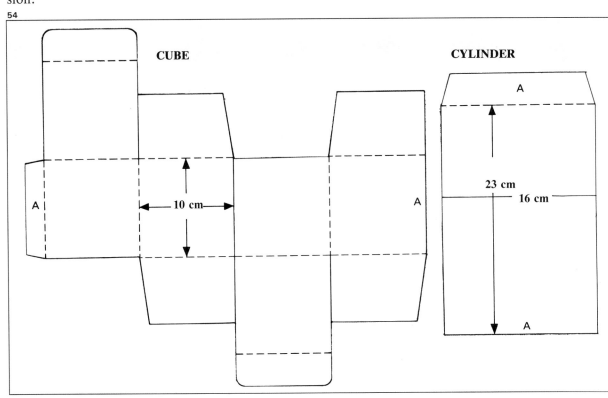

CUBE CYLINDER

A 10 cm A

23 cm 16 cm

A A

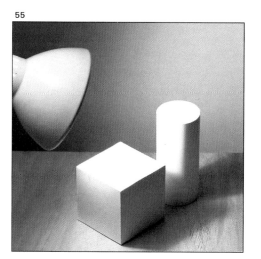

55

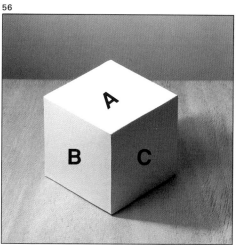

56

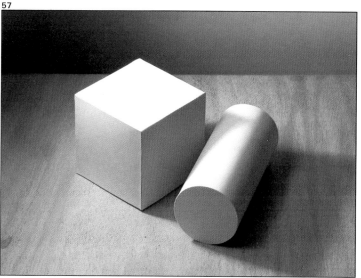

57

Fig. 55. Notice the position of the desk lamp when lighting these two basic forms.

Fig. 56. Lighted in this way, and positioned as in the diagram, the cube offers only a few well-defined values.

Fig. 57. When the cylinder is placed next to the cube, shadows and tonal values become more complicated and diverse.

There you can see it, in Figure 56: With the light almost on top of it, we see one side brightly lighted (value A: white), another side less strongly lighted (value B: pale gray) and the side opposite the light completely in shadow (value C: dark gray). Three simple, concrete values, easy to compare.

Now place the cylinder beside the cube as shown in Figure 57. Study the effects of light and shade produced. (A professional artist would also stop at this point to contemplate the model for a time, studying its structure, height, width, values, and contrasts.) But let us focus on the scale of values in our structure of cube and cylinder.

This is more complicated, isn't it? Now it is no longer possible to separate and classify values as easily as on the flat sides of the cube. What we see now is the gradations of tone created by the cylinder; a reflection at the edge of the real shadow, a cast shadow projected by the cube over the cylinder, and one, two, three, four . . . a series of different values, sometimes similar to others, sometimes not.

How does the expert artist give each tone its correct relative value within this wide and complicated range?

Building Up a Gradation of Tones

The principles that follow can be applied generally in drawing and painting, for, as you know, the sphere and the cylinder are basic forms that exist in an infinity of objects. (The human figure is one example, with its cylindrical and spherical shapes in the arms, legs, torso, head, and so on.)

The first step in drawing such a gradation is to study where the shadow begins and ends, how much space is covered by the reflection, which areas receive light and where the brightest highlight, if it exists, is found.

We then divide up the curved surfaces into various planes, giving each the value we see in the model. This entails seeing where each shadow begins, where it is strongest, and so on (Fig. 58).

Now, this division of the gradation into schematic form, such as in Fig. 58, is not normal practice. Instead we lightly sketch the gradation, avoiding sudden transitions from one tone to another, so that we can blend tones into each other more easily and achieve a good gradation (Fig. 59).

Finally, observe the difference between a gradation produced by *direct lighting*, in which there is a notable contrast between light and shade caused by the abrupt transition from one to the other, and that of the sphere and the cylinder in *diffused lighting*, with a gentle transition from light to shade with a maximum point of light that is totally white (Figs. 60 and 61).

Figs. 58 and 59. A gradation is built up through a series of progressively darker areas, bearing in mind the effect of the reflected light (Fig. 58). But these series of strokes must be drawn with spontaneity, for mechanical shading will bring about a *pompier* effect, as the French would say: overdone, too perfect.

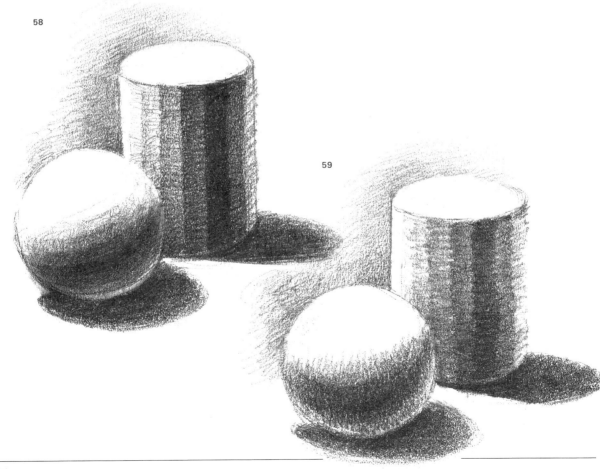

The Direction of Drawing

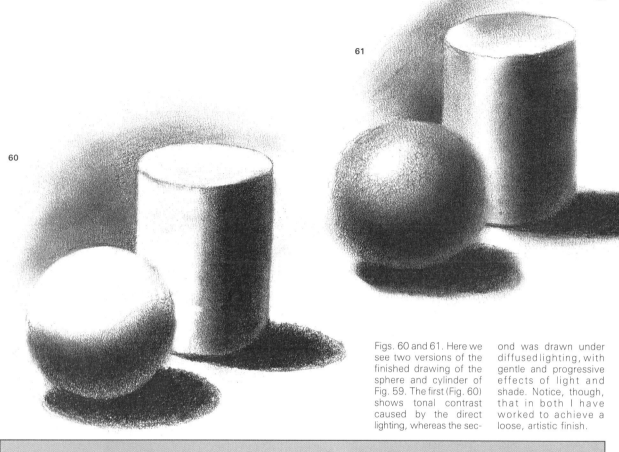

60

61

Figs. 60 and 61. Here we see two versions of the finished drawing of the sphere and cylinder of Fig. 59. The first (Fig. 60) shows tonal contrast caused by the direct lighting, whereas the second was drawn under diffused lighting, with gentle and progressive effects of light and shade. Notice, though, that in both I have worked to achieve a loose, artistic finish.

Your Line Must Enclose the Shape of the Model

Whether you are working in pencil, with a stump, with your fingers, or with a brush, you must always *enclose the form* in your drawing, blending, or painting. Imagine that the form is in three dimensions and model it in the direction most appropriate for capturing the sense of relief.

No hard-and-fast rule exists on this point, but we can say that, generally, your drawing should:

a) *be in a circular direction when you are drawing cylindrical objects.*

b) *be in a spherical direction when you are drawing spherical shapes (Fig. 62).*

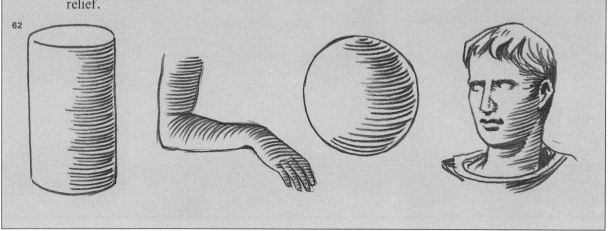

62

The Art of Valuing and Modeling

The key rule to follow when seeking to render the values of a model is to *compare*.

COMPARE

Yes, compare. We should repeat this *ad infinitum*, for we compare an infinity of times when we are drawing. Comparison comes through *observation*, through concentrating all our attention on a particular value until the tone is engraved on our memory, so that we can compare it with others.

Now, when it comes to drawing light, we need to remember a number of rules that will help us to make this comparison:

First rule: Observe and draw the light right from the start.
(And when we say light we also mean shade, for shade is nothing more than an absence of light.)
From now on, when you draw, try to see the objects around you as being made up of innumerable surfaces modeled by light. Do not look at them as you have until now, in linear fashion, as being made up of lines. That is not what they are.

As you draw, remember all the time that the shape of things is given by patches, by shaded areas that in many cases do not have well-defined limits, such as this cylinder or the sphere which we have been looking at.

The ideal would be to draw right away in grays and gradations, without lines of reference. Then we would truly be drawing what we have before us: *light*.

This is not impossible. I have done it myself, drawing nudes from life in order to study the modeling. It is difficult, of course, and in any case is not recommended at this stage. But you can begin to approach this ideal way of drawing by observing the light, approaching it, drawing with fewer lines.

Practice this rule of seeing and drawing light from the time you begin drawing. With this in mind, let's draw the cube and the cylinder we have before us. Follow me:

(Figs. 63 and 64) Pencil, paper . . . I'll begin. I observe and compare dimensions and proportions. Let's see: so high, so wide . . . I draw the contours, adjust them, this line that runs off here, this other one . . . and there it is! Do you see? It is instinctive! I still have not drawn the cylinder and my pencil is already shading in the darker side of the cube!

63

64

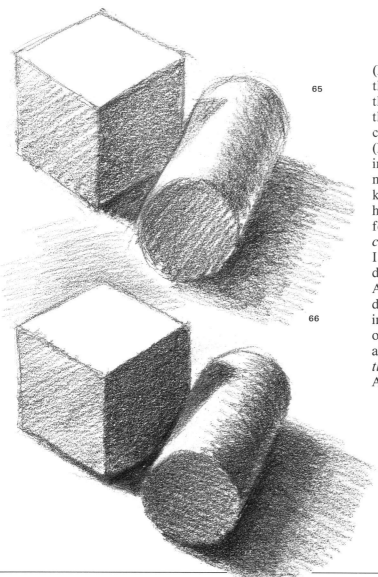

65

66

(Fig. 65) Now the cylinder: a circle like this, a line on each side, a semicircle at the end, then the shadow on the side— the shadows cast by the cube and the cylinder itself.

(Fig. 66) I'm still working on the framing of my drawing, trying to capture more the modeling than the form. I darken the cast shadows, graying in the left-hand side, now working a little on the form of the cylinder, comparing, always *comparing*, one value with others, those I have already drawn with those I am drawing now.

All the time I am looking, comparing, drawing . . . looking, comparing, drawing . . . you get to a point where the scale of values is engraved in your memory and you can say *"This tone is just a little darker than that."*

And you draw it. And it is right.

Second rule: Value gradually.

Now we are at the second stage, when the construction of the model has been outlined, including shading, and we have to adjust likeness and value.

Likeness, which refers to form, and value, which refers to light, have to be perfected gradually and simultaneously. We cannot, for instance, completely finish our drawing of the cube and then go on to finish the cylinder. By no means. This is a common beginner's error that you must avoid at all costs. You will never see a professional finishing a piece section by section, working on just one area at a time independently of the rest of the drawing. The expert artist constructs, values, and finishes the whole work at the same time.

An image should gradually appear, be drawn and formed, and have details added progressively. That is good artistic drawing.

And that is how to value: progressively.

The Art of Valuing in Practice

So that you reach a better understanding of the rules given on the previous page, let us now put aside our cube and cylinder and imagine an abstract model without concrete or figurative form, a model in which there are only five tones or different values: white, light gray, medium gray, dark gray, and black. You can see it in Figure 67.

In the next illustration, Figure 68, we can see this model once the construction and framing stage is complete, including shadow. Note that shadow at this stage is only lightly shaded in, sketched.

At this stage of gradual valuing, I begin by drawing the black of the model, concentrating on getting a deep black. Here there are no problems of comparison. Black? Just keep on darkening until you get it right. This black and the white of the paper itself will now help me to render the other tones, especially the dark gray at the bottom of the picture, as I gradually darken the tones until they approach the values I see before me (Fig. 69).

At this point, the only thing we need to be careful about is not to go too far. We gradually heighten values, darkening the grays progressively but with moderation, making sure that we do not make one value too dark, which would lead us to darken the others.

Slowly, progressively, classifying and comparing, *always comparing*, why shouldn't we be able to reproduce exactly the tones of the model?

Third rule: The starting point for valuing is fixed values.

Before we begin to draw lines, before we have drawn in the lightest shadow, there is already an established value on our drawing paper, an exact tone "already drawn in":

The white of the paper

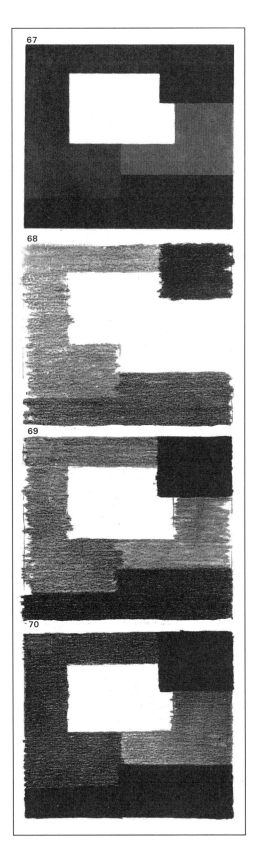

Figs. 67 to 70. The step-by-step process of rendering tonal values in an abstract image is illustrated here. At the top, the model; below this, the gradual sequence showing the process described in the text on this page.

Half-Closing the Eyes

In the same way, it would be hard to find a model that did not have an area, no matter how small, that was absolutely black.

Absolute black

With these two fixed values, in which we know there is no possibility of error, it is much easier to adjust and render the intermediate values.

Let us now discuss one of the most frequently used techniques of the artist when studying value and contrast:

The Old Trick of Half-Closing the Eyes
Half-closing the eyes here means not completely closing them, or closing them as when you are tired or sleepy and your eyelids start to droop, but in such a way as to keep the eyes and mind alert. You have to half-close your eyes nervously, with a slight contraction of the tiny muscles that move the skin of the eyelids and the part below the eyes (Fig. 71).

What happens when we look at things with our eyes half-closed? Two important things:

1. *Small details are eliminated from our view of things.*
2. *We appreciate contrast much more.*

The first of these advantages means that we see almost exclusively tones, colors. When we half-close our eyes, the image we see becomes less sharp, as if out of focus or blurred. Detail, "the small drawing," is lost, but color and tone come to the fore (Figs. 72A and 72B). Objects lose their usual clarity, becoming a little darker and heightening contrast. In consequence of this, you can then appreciate better the contrasts of the model and make a more accurate comparison of one tone with another.

Figs. 71, 72A, and 72B. If you look at a model through half-closed eyes, you will see it without the small details and will be better able to capture overall forms and tonal contrast.

71

72A

72B

Blending with the Fingers

Advantages and Possibilities Offered by Blending with the Fingers

Comparing this technique with the better-known use of the paper stump to tone down and harmonize drawings, we could mention that fingers come free and in several sizes, that we can wash our fingers but not a stump, and so on. But, on their own, these are not really important enough reasons to justify the use of the fingers. The main reason is that our fingers have *different* characteristics.

For our fingers are *soft* and *moist*, and they *allow us to work directly*.

When you blend with your fingers, it is really you who are drawing, for you are not drawing with a pencil or a stump, but with a sensitive part of yourself that works directly, better suited to obey your will, your desire to shade, to tone down, to darken, and so on. For this reason, shadows and forms drawn with the fingers are warmer, more full of life than those applied with a stump, and this is why expert artists frequently resort to this technique.

Moreover, our fingers are *soft*, with a special softness that adapts to the roughness of the paper, entering into the tiniest, most inaccessible craters on the paper and filling them with the lead of our pencil lines. The stump is also soft, but it does not achieve this extraordinary efficiency.

Finally, the fingers are *moist*. To understand the advantages of this quality, imagine dipping your finger in water, then rubbing it vigorously over an area of paper previously shaded in with a 2B pencil. If you do this, you will see that the water dilutes the graphite, just as a brush dipped in watercolor does. Well, using the finger for blending produces much the same effect, but on a much smaller scale, since the natural transpiration of the fingers under normal conditions is practically imperceptible. It is there, though, constantly flowing, and the moisture produced is slightly greasy. What more do we need to know in order to understand the action of the fingers on the properties of graphite in producing grays, gradations, and blacks, whether velvety, strong, or fine?

What to Use

The fingers, obviously, but look at the illustrations and follow the text on the next page to see with exactly what part of the fingers. Study the position and movement of the fingers and how they can be used to blend different kinds of areas.

Figure 74. The five fingers of the right hand, some more than others, are what a right-handed artist uses for blending. We use the different parts indicated in the picture, bearing in mind that:

73

A) In exceptional cases, to harmonize large areas such as backgrounds, we use the part of the palm labeled A.

B) The parts labeled B are generally used for regular-size areas and even small areas.

C) The parts labeled C are used for smaller, more clearly defined, shaded areas.

While you are gradually valuing, you should also blend with your fingers and draw with your pencil, working hard at darkening until you get the tone you want. This you do *without putting your pencil down*, alternating between using the fingers and the pencil in an instinctive, automatic movement. In the illustrations, you can see the position of the pencil in the hand while the artist blends with his fingers. To blend small areas, use one side of the finger, drawing with the part of the fingertip close to the nail, which provides you with a more accurate "stump." The fingers most used for these smaller areas are the ring and little fingers and, to a lesser extent, the middle finger (Figs. 75 to 80).

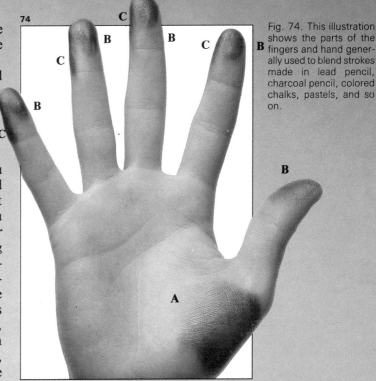

Fig. 74. This illustration shows the parts of the fingers and hand generally used to blend strokes made in lead pencil, charcoal pencil, colored chalks, pastels, and so on.

Figs. 75 to 80. Some examples of blending with the fingers. In the three illustrations at the top, the fingertips have been used, and in the bottom three, the sides of the fingers close to the nails.

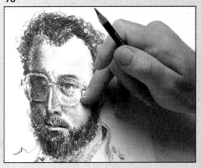
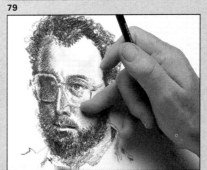
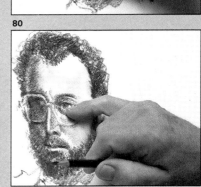
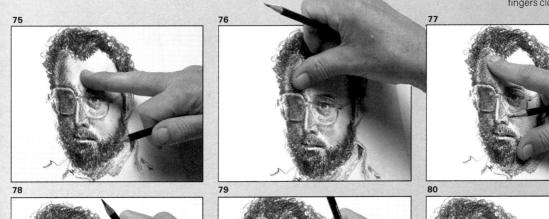

How to Blend Evenly

Practically anyting you can do with a stump can also be done with the fingers, even blending a very small area such as the eyelashes or the eyebrows in a portrait. In such a case, you would have to use a rubber eraser too, but it can be done, and is done.

The stump, on the other hand, cannot produce certain effects that can be achieved by using the fingers and their moisture.

And now you are going to see this for yourself. Take a soft pencil and prepare to draw, using any type of drawing paper. Hold the stick of your pencil inside your hand, with the drawing board supported at an almost vertical position and your arm stretched out.

Now draw, if you will, a uniform gray patch with a soft pencil such as a 2B. But wait a moment. On the subject of

gray patches that will later be blended, let us discuss a point that is equally valid whether you are using your fingers or a stump.

By uniform gray we mean a gray patch all of the same tone, in which no line or area stands out against the others, such as that in Figure 81.

You will never quite manage to blend a completely uniform, perfectly harmonized gray unless you use as your starting point a harmonized patch made with the pencil.

Well, let us go back to our uniform gray patch, medium tone, fairly strong. Now blend the upper central area with a clean stump (Fig. 85A). Now do the same thing again, blending this time the central lower area with your finger. Rub the tip of your middle finger over the patch you made in pencil (Fig. 85B).

Figs. 81 to 84. If you draw a gradation (in lead pencil, charcoal, or pastels—it makes no difference) regularly, with absolutely uniform strokes, as in Fig. 81, when you come to blending it, the shading will be perfect, with no irregularities (Fig. 83). But, if your original strokes are haphazard, lacking in uniformity (Fig. 82) the resulting gradation will be dirty, imperfect even when blended (Fig. 84).

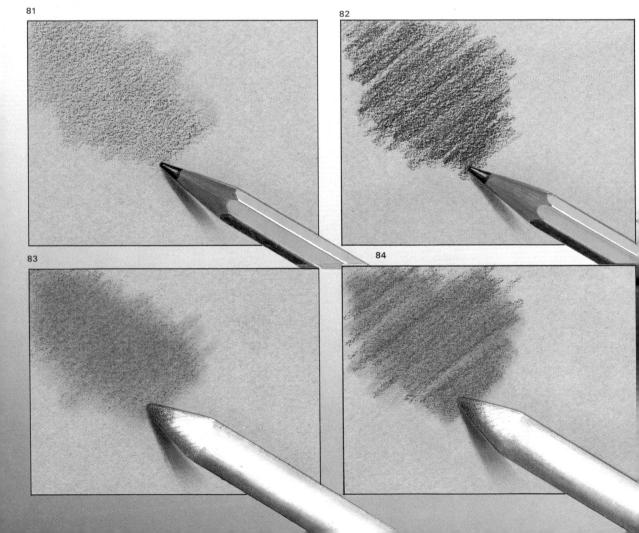

81

82

83

84

Are you rubbing?

Harder, harder. Remember how hard you rubbed with the stump.

No, no, no. Harder, MUCH HARDER! Don't be afraid. You must rub your fingertip vigorously, press, flatten your finger against the paper . . . until your skin gets hot from the friction.

"Hey, but . . . !"

That's it, *until your skin gets hot.* Would you do that again, please?

Look, look how the gray tone gets stronger! Do you see how, blending now with one finger, now with another, hard, without pause, the area gradually becomes darker? (Fig. 85B).

Indeed, if you do it correctly, blending can darken a dark gray patch made with pencil until it becomes completely black. The reason for this is quite logical if you remember the special quality of the fingers: *they are moist.*

Transpiration Stains

That's right, a sweat stain from the hand or finger that may not be visible against the white of the paper will appear later, *when you draw over it*—blending, for instance, a uniform gray. Remember, too,

85

that while you blend with your fingers, your sweat combines with the lead picked up on your fingertips and can actually produce paint, and that this happens with the finger you are *not using,* while you are blending with another finger! So be very careful when changing blending fingers in summer!

Q: *How do you clean a stump?*
A: *By rubbing fairly hard on a paper with a certain amount of grain, then cleaning what rubbed off with an ordinary cloth.*

Q: *What should I do when my stump gets blunt?*
A: *Sharpen it with a fine-grain piece of sandpaper, which will also leave your stump perfectly clean.*

86

How to Make Dark Black

Speaking of black tones and the intensity of black you can achieve, I will now speak a little of a basic problem some amateur painters have: a general lack of shading in their drawings.

(If you can already get absolutely black tones in your work, skip these lines; they are not for you. Carry on as you were, drawing black where you see black, getting all the tones you need from this in order to draw light.)

I am speaking of drawings in which totally black tones do not exist, drawings I have occasionally had the chance to talk about with the artists themselves. Many amateurs have to work at getting

are the same as in the original drawings. No, a lack of intense black is not caused by the pencil but by the lack of experience of the hand doing the drawing. Perhaps this hand works a little nervously, with too much prudence, afraid of blackening too much. No, please! You have to overcome this fear; remember that it is better to make a mistake in drawing than to draw in this inhibited way, which does not let you develop or express your whole personality as an artist.

Draw black where you see black. But make it *black*, ABSOLUTELY BLACK. Try it now, hold your pencil in the nor-

Fig. 87. If you use a semisoft pencil, an HB or B, you will never get absolute black. This type of pencil is fine for initial drawing, for structuring or framing the model, and also for drawing lighter shadows at the early stages of valuing (Fig. 87A). But to get intense, absolute black tones, you need to use a soft 2B or 4B, even a 9B (Fig. 87B).

87

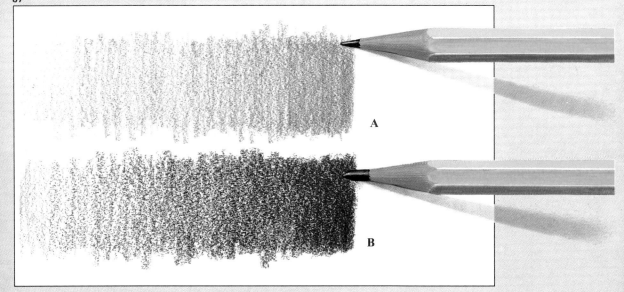

A

B

darker shades to give more contrast, greater tonal richness, and a more faithful reproduction of the range of tones found in the model.

Let us begin by saying that a 2B or 4B pencil can, and does, give blacks of the intensity that you see in the illustration on the facing page. What may vary is the quality of these blacks—that is, they may be matte blacks instead of glossy and may sometimes have a slightly bluish tone. This is because print can never produce the same quality as the original. But the intensity, the blackness, the strength of the blacks in relation to the light and dark grays do not vary and

mal way, perpendicular to the surface of the paper, drawing straight downward, and press, press with all your might! Press until you are about to break the lead (Fig. 87B).

Break the lead, even. Break it over and over again, but draw hard, *pressing into the paper, flattening the grain, the roughness*.

That way, of course you will get dark blacks!

Fig. 88. (opposite). This is a pencil drawing of a plaster reproduction of Michelangelo's *The Slave*. I drew this splendid head with the idea in mind of solving all the problems of light and shade a model can present. To achieve this, I had to take into account the illuminated areas and forms that project shadows—the eye, nose, mouth, chin, and so on. I also had to study closely the features in shadow—the ear, jaw, and neck—where a chiaroscuro effect was required.

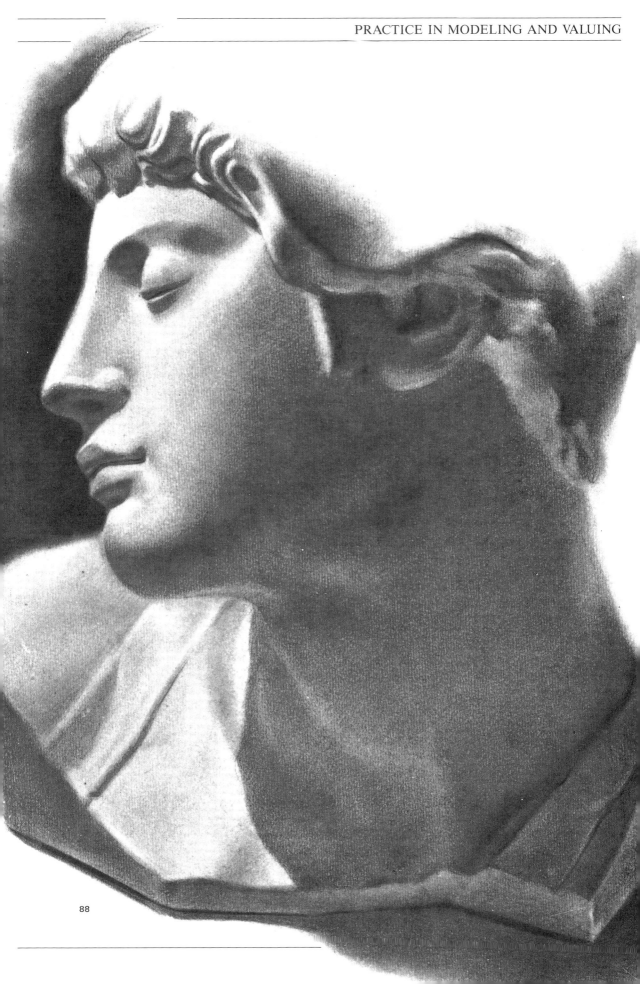

Drawing Drapery: A Necessary Technique

Leonardo da Vinci, Albrecht Dürer, Eugène Delacroix, Edgar Degas—all the great masters practiced drawing or painting a cloth, a robe, an article of clothing spread over the lap of a figure, on the back of a chair, on the floor, and so on. This exercise has two useful purposes. First, studying the structure of creases on a cloth teaches the artist to render its appearance or texture so that by just looking at the picture, we know whether the cloth is made of cotton, thick wool, smooth silk, or what. This is of practical use when we come to paint a dressed figure or the folds of a sheet or tablecloth in a still life. Creases in cloth also provide an ideal exercise in the study of values, the effects of light and shade, and tones, hues, and reflections. I recommend that you carry out this exercise. In fine arts it is known as drapery study and is a more or less obligatory subject.

For this exercise, you will need the following items: a white cotton cloth measuring some 40×60 cm (16×24 inches),

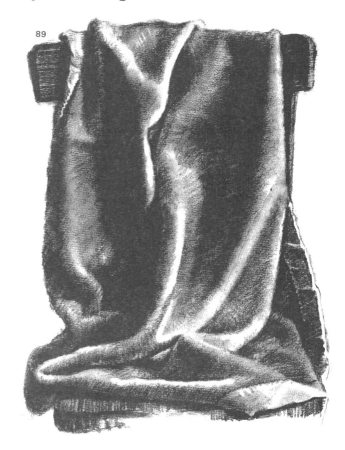

89

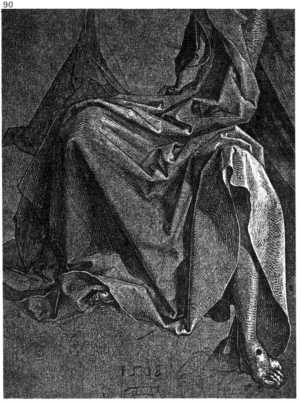

90

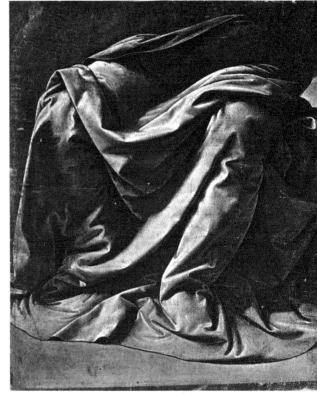

91

strong enough to stay fairly rigid and to form the type of creases you can see in Figure 96; a few tacks or pushpins; a wall or large bulletin board into which you can stick them; and an adjustable lamp to light the cloth. Obviously, you also need a sheet of good-quality drawing paper (smooth or fine-grain), a malleable rubber eraser for rubbing out pencil, and two pencils: an HB for the outline and initial structure and a soft 4B or 6B for drawing the effects of light and shade. I worked with an HB and a mechanical pencil with a 6B lead.

Now, following the example of the illustrations on this page, position your cloth at a slight angle, attaching it to the wall with two tacks, as in Figure 93. Next, fold the cloth over to the left, covering the tacks that fix it to the wall, and place a third tack going through the material but *not into the wall*, about 14 cm (5½ inches) from the upper edge and 17 cm (7 inches) from the left-hand edge (Fig. 94). Finally, fix this third tack to the wall, moving it about 8 cm (3 inches) to the right, below the first, which is now hidden by the folded cloth (Fig. 95). As you move and fix this third tack, a series of creases and folds will be formed, and you can arrange them for a result similar to Figure 96.

Figs. 89 to 91 (opposite). No artist's training is complete without the study of drawing drapery. Above is a study of a blanket I produced for this book. Below are two studies of drapery by Albrecht Dürer and Leonardo da Vinci, respectively.

Figs. 92 to 96. I would like you to draw a white cloth some 40 × 60 cm (16 × 24 inches), pinned to the wall and lighted by an adjustable lamp. Pin it to the wall at an angle with two tacks (Fig. 93); fold it to the left (Fig. 94); and fix this fold to the wall with a third drawing pin (Fig. 95), creating the creased form you can see in Fig. 96.

92

93

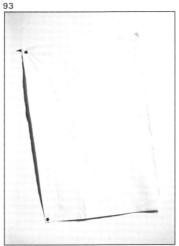

96

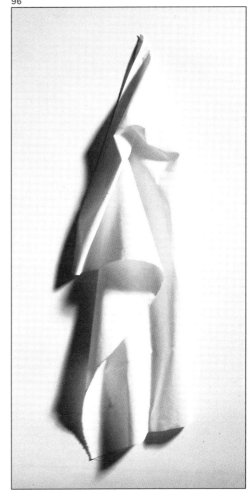

94

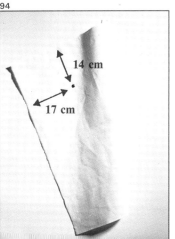

14 cm

17 cm

95

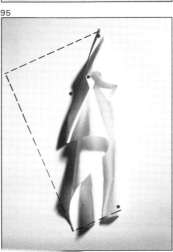

Stage One

Begin with the outline, the basic structure. Draw faintly, and compare proportions and sizes. Remember to work on everything at once, gradually adjusting the likeness to the model. Then begin to value generally with loose pencil strokes, half-closing your eyes to compare values. In the illustrations on this page, you can see the different directions of the pencil strokes. They have a clearly diagonal tendency, but always aim to enclose the form. Study how the stroke aims to take in the form in Figure 98. Note that the cylindrical fold on the left and the shadow cast onto the wall have been drawn through a series of crossed strokes.

Figs. 97 to 99. These three illustrations show the early process of sketching the cloth. Note the simultaneous actions of drawing the basic lines and of shading. Fig. 99 shows the drawing on completion of this first stage.

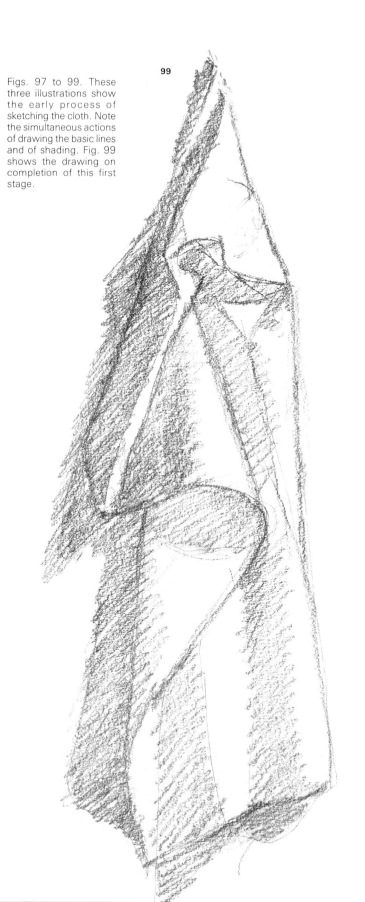

99

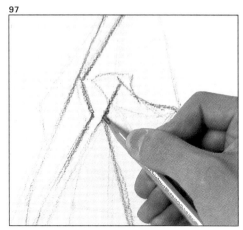

97

98

Stage Two

Finally, notice how the series of gradations that make up the cylindrical shape of the folds have been applied through a number of nervous zigzag strokes, pressing hard with the pencil in one direction and hardly touching the paper in the other. Zigzag, zigzag, zigzag, very quickly.

In this drawing, when necessary, I have at times ignored the rule that the stroke must enclose the form, and have drawn with vertical, slanting, or curved lines according to the contours of certain forms and shadows.

What about the eraser? Have I used it at this stage? Well, yes, I used it from time to time, not to "draw," but to correct small imprecisions in my construction, in the outline of forms, of shadows, and so on.

Figs. 100 to 102. This next stage involves valuing through zigzag strokes of the pencil. The hand quickly moves back and forth to adjust forms and contours, occasionally with the help of the rubber eraser. At this stage of shading and drawing, we can already see a first approximation to value and modeling.

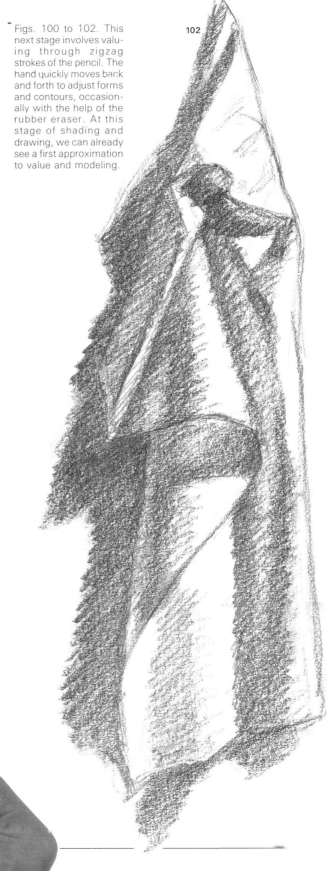

Stage Three

Blend the whole drawing with your fingers, even lightly graying the whites of your picture. Reinforce the dark areas with a number 2 pencil, continue to improve the drawing's likeness to the model, and correct mistakes with your rubber eraser.

If you compare the finished drawing in Figure 104 with the illustration in Figure 103, you will notice a remarkable fact. This is that in the latter *there is only one white*, a dirty white produced deliberately with the fingers. In Figure 104, *there are two whites*, the same dirty white of the earlier version and a bright, absolute white which I achieved with the eraser, "drawing" with it in certain areas to accentuate the essentially cylindrical forms of the model.

Take good note of this difference, which can help you to understand why you have to "dirty" the whites at this second stage, the stage of preliminary blending in which I used only my fingers. This technique is wholly appropriate to a drawing so full of curved forms, which are best modeled through a direct, soft, moist medium. For this reason the fingers are ideal for this kind of blending. When working in this way, always remember the following:

Use your fingers to blend in a circular fashion, closing and modeling the form.

You also have to use your rubber eraser frequently at this stage, to strengthen outlines that the fingers cannot adjust, to perfect the construction of the model, and so on.

The rest can be summarized in just a few words: *value through comparison, intensify, harmonize. Work at everything, do everything at the same time.*

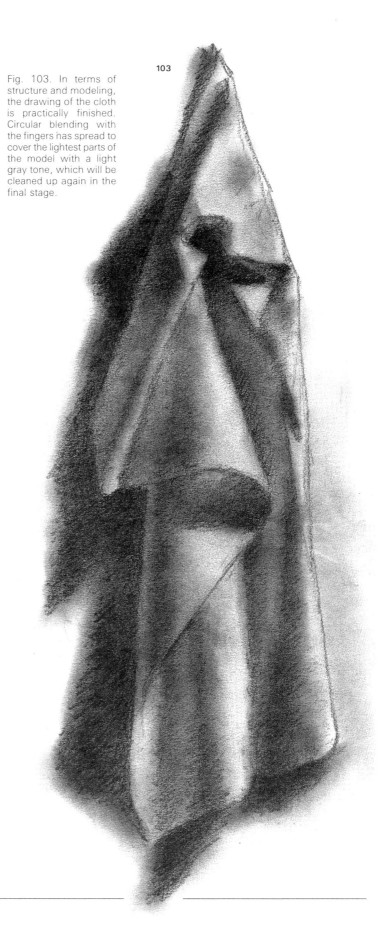

103

Fig. 103. In terms of structure and modeling, the drawing of the cloth is practically finished. Circular blending with the fingers has spread to cover the lightest parts of the model with a light gray tone, which will be cleaned up again in the final stage.

The Finished Drawing

Be extra careful when comparing values! Half-close your eyes, observe, classify, compare.

Study, classify tones, observe slight variations; those lights in the shadow, the chiaroscuro, which is more complicated in this model. Be careful not to overdo your tones!

Intensify the darker areas with a number 1 pencil.
Toward the end, draw the light gray of the background.

I could have done this before, but I left it to the end because of its relative unimportance. What is important, though, is to see that on the left-hand side the background is a little darker than on the right. It is a good idea to put in a "provoked contrast" here, to make the edge of the cloth stand out more on this side. You can see this contrast, caused by the faint halo of light, in the illustration on this page.
Another very important task is that of perfectly harmonizing the background.

Study the reflections. Remember that the shadow has a "hump."

Andrew Loomis, a famous American artist, author of several books on illustrating, calls the part of the shadow between the reflection and the lighted area—the part where the darkness is at its strongest—"the hump of the shadow." This seems to me such a graphic definition that I do not hesitate to use it here. Wherever there is a reflection, there is a "hump." Notice it in this drawing and remember it. Study the position and size of this part of the shadow, and do not be afraid to darken it. When you come to draw this area, spread the graphite with your fingers as you model. Take care over the value of the reflection, bearing in mind that each reflection, each "hump," each light, and each shadow has *its own* special tone.

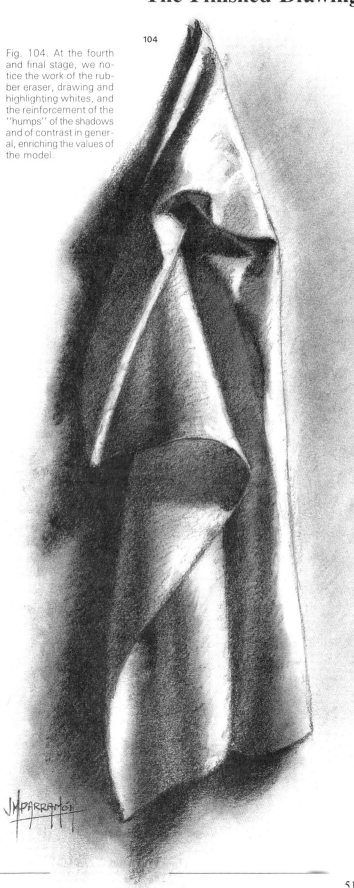

104

Fig. 104. At the fourth and final stage, we notice the work of the rubber eraser, drawing and highlighting whites, and the reinforcement of the "humps" of the shadows and of contrast in general, enriching the values of the model.

Whatever the subject, whether it be landscape or seascape, figure or still life, perspective always has a part to play. And in our case, dealing with a book about light and shade, review of the perspective of shadows is obligatory. This is an area of which few artists have a very deep knowledge, partly because, as I have said on many occasions, we are not architects; we draw and paint what we see, copying the model. On the other hand, I think a review of perspective would be a good idea because, for instance, when we draw or paint a picture outdoors, after two or three hours the sun has changed position and the shadows are therefore different. Or when we draw or paint from memory in the studio—composing a theme, creating, inventing—we need to know where shadows *would* be. In any case, it is not a question of taking up our ruler and T-square, but of knowing what perspective is, how it is achieved, and how it is drawn. This knowledge allows us to represent shadows in perspective in an artistic way.

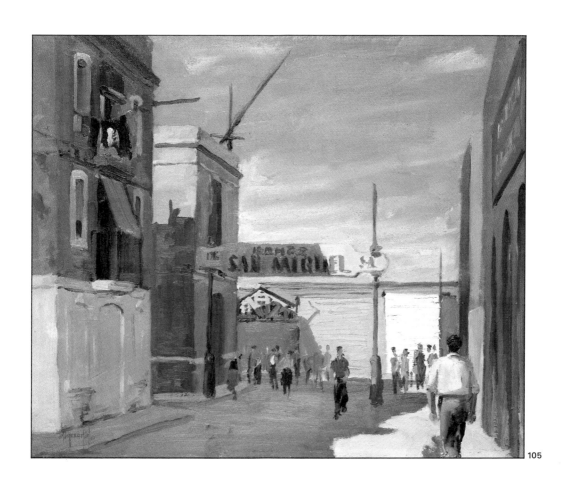

105

The Perspective
of Shadows

The Basics of Perspective

Whereas the sculptor works in three dimensions (height, width, and depth), we painters work in only two: height and width. The third dimension, depth, we have to simulate, to represent with the help of two factors:

Volume

Perspective

Volume is achieved through effects of light and shade, while perspective is established through a series of lines or forms that converge toward one or more determined points. We are now going to look at perspective as applied to the effects of light and shade, that is to say, *the perspective of shadows*.

The first thing we have to do is to remember the two basic elements of perspective in general:

The horizon line (H.L.)

Vanishing points (V.P.)

Note that in the illustrations on this page (Fig. 106 to 108), the horizon line coincides with the point where sea and sky meet, and that this line appears at eye level to the observer, lowering with him when he bends down and rising when he goes to a higher viewpoint.

In Figs. 109 and 110, we see how lines converge on various *vanishing points*, and that these two figures correspond to two types of perspective:

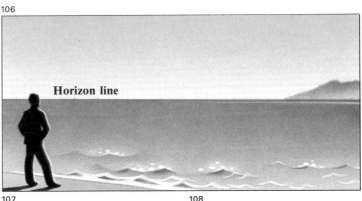

106

Horizon line

107

108

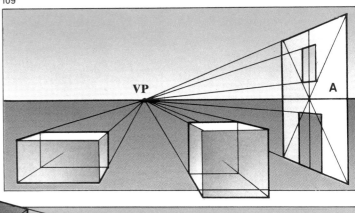

109

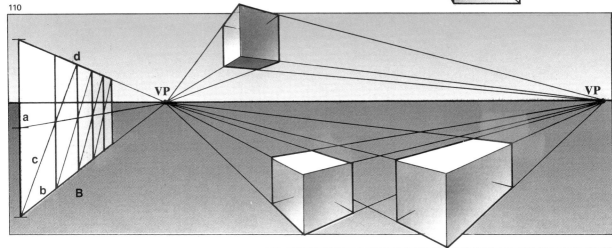

110

1. With parallel perspective, to one vanishing point (Fig. 109)

2. With oblique perspective, to two vanishing points (Fig. 110)

The single vanishing point in parallel perspective is where perpendicular parallel lines join the horizon (Fig. 109). The two vanishing points in oblique perspective are where the lines formed by different sides of cubes meet the horizon (Fig. 110). Note that parallel perspective applies when one side of a cube faces us head-on; oblique perspective applies when an edge of the cube faces us instead, so that we can see two sides that are perpendicular to each other. You can also see in these figures two simple formulas for finding the center of perspective of a space (point A in Fig. 109) and for dividing an area into a number of equal spaces to calculate perspective (point B in Fig. 110). In the latter example, you first draw line a to divide the height of the space, then roughly calculate the depth b and draw the diagonal line c to find point d, from which you can draw the series of diagonal and vertical lines that form the divisions in depth and perspective.

In Figures 111 and 112 on the opposite page is a photo of Piazza Santa Maria in Venice, and another taken in the port of Amsterdam, examples of parallel perspective with one vanishing point and of oblique perspective with two vanishing points. Observe the cubes in perspective that have been added to the photos, the straight lines of their edges going off toward the horizon line, showing how depth, the third dimension, can be represented, even though we are only working with height and width.

Fig. 105 (previous page): José M. Parramón, *District by the Sea*. Private collection.

Figs. 106 to 110. The horizon line is always at eye level to us, and rises or falls if we raise or lower our own position. The two diagrams at the bottom of the page are ex-

amples of parallel perspective with one point and oblique perspective with two points.

Figs. 111 and 112. These photos are also examples of parallel perspective with one vanishing point and oblique perspective with two vanishing points.

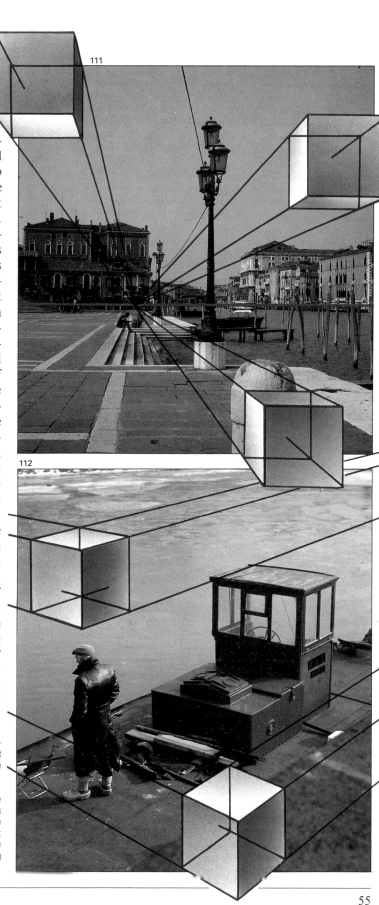

111

112

The Perspective of Shadows in Natural Light

113

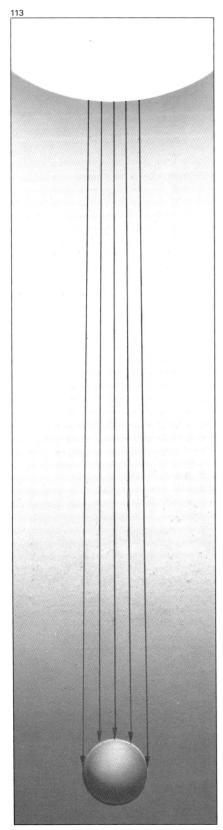

114

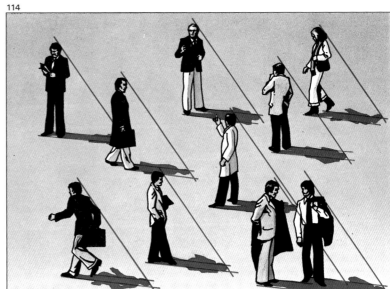

As you know, light moves in a straight line, radially. But the sun is infinitely larger than the earth and is millions of miles away from it. For all practical purposes, this enormous distance eliminates the radial quality of the light arriving from the sun, allowing us to state that:

**Natural light spreads in
parallel lines.** (See Fig. 113.)

This aspect of the behavior of natural light has an additional consequence:

**Shadows projected by natural
light have practically no perspective.**
(See Fig. 114.)

This is perfectly logical if we remember that a shadow is nothing more than a patch on the plane onto which it is cast, and therefore has no form of its own.

On the other hand, the shadow cast by the sun can be projected to one side of, in front of, or behind an object. It can be long or short and can even practically disappear, according to the sun's position or whether it is dawn or midday. In the figures on the opposite page you can see the different directions and dimensions that a shadow cast by the sun can take.

Figs. 113 and 114. The huge distance from the sun to the earth causes sunlight to shine in parallel lines. For this reason, when we see objects from a position higher up, the shadows they cast fall parallel to each other.

Natural Light: Parallel Projection

Figs. 115 to 120. Natural light shines in parallel lines. According to whether the sun is higher or lower in the sky, cast shadows are longer or shorter.

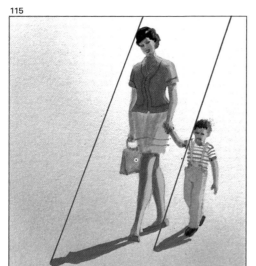

115

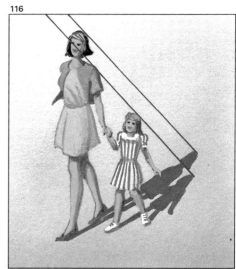

116

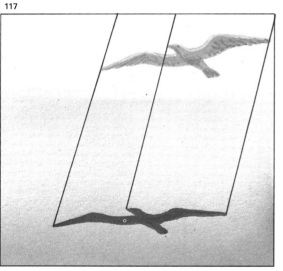

117

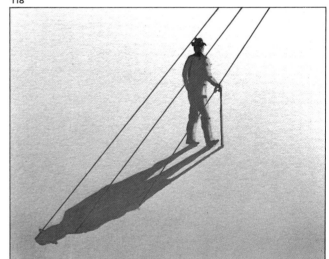

118

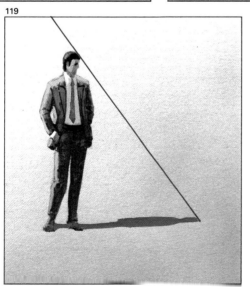

119

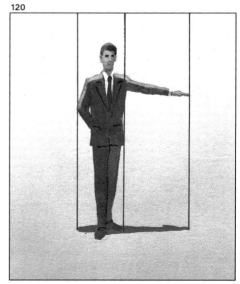

120

Vanishing Point of Shadows (VPS)

121

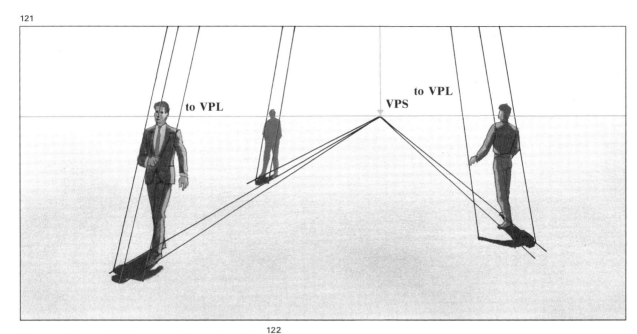

To continue, shadows cast by natural light have practically no perspective. However, when they are touching the ground, all objects and the shadows cast by them are subject to the horizon line and to the effects of perspective, in this case *parallel perspective with one vanishing point*. This is because the rays of the sun move in parallel lines, explained by the fact that the sun lights one half of the earth (see Fig. 113), a huge area whose center of perspective has to be placed on the horizon. Consequently, we do indeed have vanishing points:

The vanishing point of shadows (VPS)

and the vanishing point of the angle of light (VPL)

We call the vanishing point of the angle of light the VPL (Vanishing Point of Light) because of its direct relation to the rays of light from the sun and because, as we shall see when we come to study artificial light, the *point of light*, which in the case of artificial light is the light bulb, here and now is the sun.

And we have two formulas or methods:

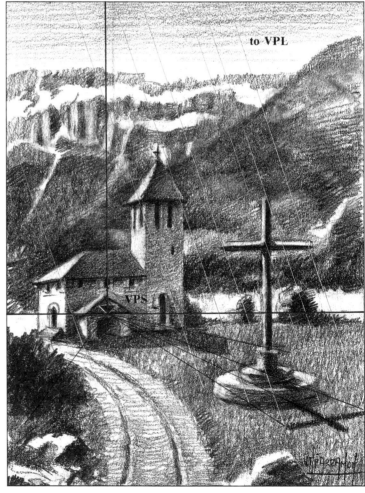

Vanishing Point of Light (VPL)

123

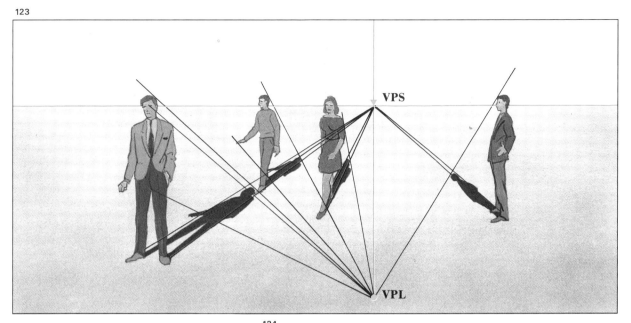

124

1. **Backlighting, which applies when the sun is behind the model (Figs. 121 and 122)**

2. **Front lighting, which applies when the sun is in front of the model (Figs. 123 and 124)**

Note and compare the differences. In the case of backlighting, the rays of the sun are practically parallel when they reach the model, while the VPS (vanishing point of the shadow) determines the length and form of the shadows (Figs. 121 and 122).

In the case of front lighting, the VPS is again on the line of the horizon, directly before us and in coincidence with the line of our viewpoint, while the VPL is level with the ground, just below the VPS, also determining the length and form of the shadows (Figs. 123 and 124).

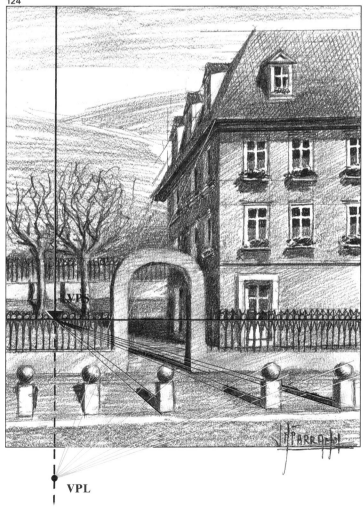

Figs. 121 and 122. When the sun is directly in front of us and the bodies we see are back-lit, the vanishing point of shadows (VPS) is the sun itself, in front of us on the horizon line.

Figs. 123 and 124. In front lighting or lateral front lighting, when the sun is behind us, the vanishing point of shadows (VPS) is still on the horizon line, but the vanishing point of light (VPL) is below the horizon line, as we can see in these illustrations.

The Perspective of Shadows in Artificial Light

125

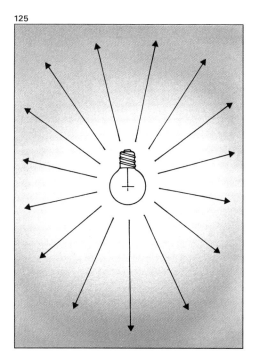

126

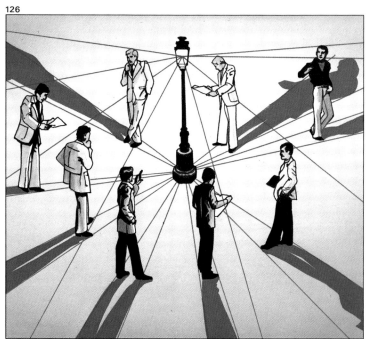

127

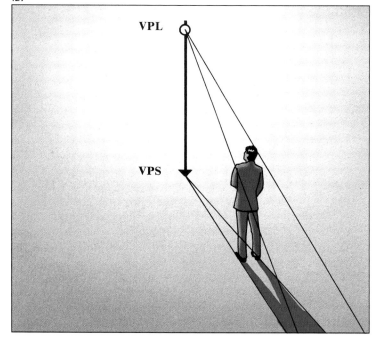

The elements are the same, the VPL and the VPS, that is the vanishing point of the light and that of the shadows, and they come into play as before, with the difference that, as you know:

Artificial light moves in straight lines, radially.

There are also differences regarding the position of the VPL and the VPS, as you can see in the illustrations on this page. Figure 125 shows the radial quality of artificial light, and the following illustration shows how the shadows cast by it also take a radial form. Finally, Figure 127 shows that the VPL (vanishing point of light) is in the light source itself and that the VPS (vanishing point of shadows) is not on the line of the horizon as with natural light, but is at ground level, exactly below the point of light. Now let's put this theory into practice. We will draw a cube and the shadow cast by it when it is in a room under artificial lighting. But we will draw the cube one part at a time, beginning with the rear face and its shadow, then the left-hand face, also with the shadow it casts, and finally the whole cube.
Let's begin.

Figs. 125 to 127. The artificial light is spreading in a radial sense; the vanishing point of light (VPL) is in the same light source and the vanishing point of shadows (VPS) is below the VPL.

Drawing the Shadow of a Cube in Oblique Perspective

Figure 128: As you can see from the labels "to VP1" and "to VP2" (vanishing points 1 and 2), I have drawn the room in oblique perspective with two vanishing points and have established the VPL (vanishing point of light) in the light bulb. After this I drew the quadrilateral corresponding to the rear of the cube, and the two lines from the light bulb, or VPL: "rays of light" A and B. By passing through corners C and D of this quadrilateral, lines A and B give us the *approximate* form of the shadow cast by the rear face of the cube. I say *approximate* because to get the exact shape we have to establish the VPS, or vanishing point of the shadows.

Figure 129: Here it is, on the right of this lateral face of the cube, *on the plane of the ground*, exactly below the vanishing point of the light (VPL). To find the exact position on the ground of this point, you have to do the following: First draw a vertical line from the VPL to the ground. Then *project in perspective* the position of the vanishing point of light or VPL. This is easily done by drawing a line in perspective (to VP2 in this case) from the point of light to the point where wall and ceiling meet (a'), then a vertical line to the point where wall and floor meet (b') and a line in perspective from point b' to VP2, which will establish the VPS. Now draw lines C and D to the vertices of the square (points E and F) and continue them until they meet "rays" A and B. That is all. We now know the length and exact form of the cast shadow.

Figure 130: I have now finished my drawing of the cube and the shadow cast by it. It only remains for me to point out that I drew the cube as if it were transparent in order to establish point C, which I needed, with the help of point B, to fix the form of the shadow behind the cube. Obviously, the cube is in perspective, and its edges go off to VP1 and VP2, as does the edge of the shadow (G).

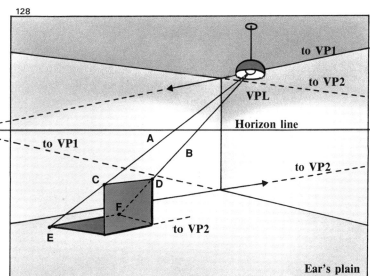

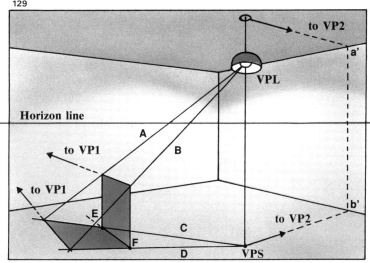

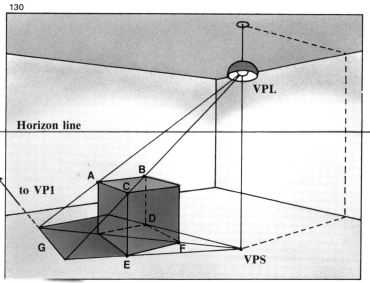

Examples of the Perspective of Shadows in Artificial Light

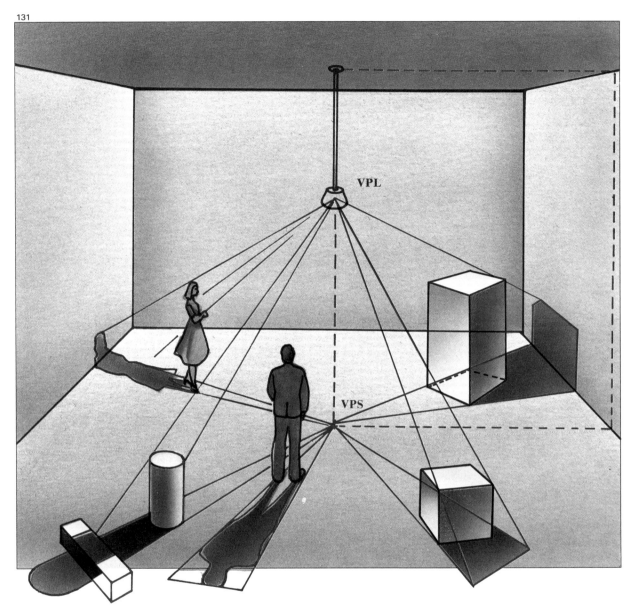

131

To extend what we have already mentioned regarding the perspective of shadows in artificial light, on this page and the next are various examples with figures and basic forms. On this page, Figure 131 shows a general summary of shadows in artificial light, in which the shadows of the woman and the oblong box are cast onto the floor, continuing on the walls, posing a typical problem of projection on two planes. The shadow of the cylinder, on the other hand, is broken up by that of an elongated oblong-shaped box lying at an angle to the former.

In the illustrations on the opposite page, the projection in perspective of the objects is determined through a combination of the vanishing points (VPL and VPS). Note, for instance, the special form taken by the shadow of the cube in Figure 132. This would be extremely difficult to interpret without the help of the vanishing points and the rules explained on these pages. Another interesting point is the shadow of the oblong box in Figure 134, cast in part onto the wall; this is almost impossible to draw correctly without the aid given by the lines from

Fig. 131. This illustration summarizes the perspective of shadows in artificial light.

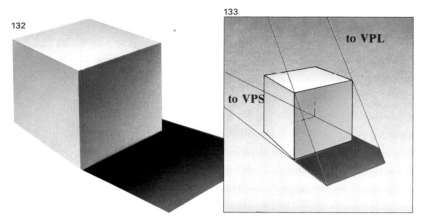

132

133

to VPL

to VPS

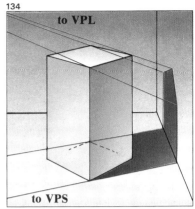

134

to VPL

to VPS

the vanishing point of the light (VPL). Study, too, the basic formula for drawing the shadow of a sphere or cylinder (Figs. 135 and 136). This problem is solved by framing the circle in a square, projecting this onto the floor and drawing the shadow cast by the circle inside this projected form with its corresponding perspective. Remember that this formula can be applied to drawing the shadows of heads in perspective, as it can to drawing all irregular or curved forms in perspective.

Why don't you now attempt to draw a cube, an oblong rectangular box, and a cylinder with their respective shadows, in positions different from those in the figures on this page? That would be an ideal review exercise to help you remember all that we have learned so far about perspective in general and the perspective of shadows in particular.

Figs. 132 to 136. To draw the shadow cast by an artificial light from real life, all we have to do is to look closely at the model. Hower, to draw this or a similar subject from memory, we need to recall the formulas explained over the last few pages. And nothing would help your memory more than practicing drawing some of these basic forms in different positions, imagining the position of the source of light, and working out the perspective of the cast shadow.

135

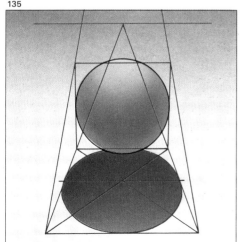

136

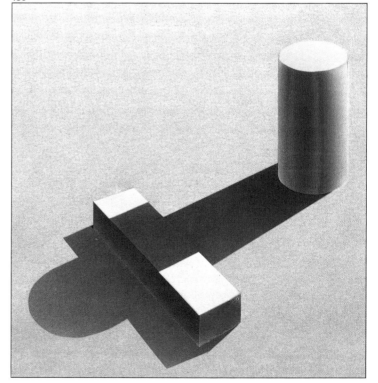

The layman may think that, since the shadow is darker, then the color of the shadow is whatever color mixed with black. "The shadow of a red book," he may think, "is dark brown, or red mixed with black; and the shadow of a tablecloth is gray, or black and white." Well, he would be wrong in thinking this. It was considered true up until one hundred and fifty years ago, when the artists of the 1840s painted shadows in *asphalt*, a dark brown they used in all the shaded areas of their pictures. But, around this time, the French chemist Eugène Chevreul established a theory of color that soon awoke the enthusiasm of the young artists of the period. Those artists were the Impressionists, who from that moment onward began to paint with light colors. They discovered that there was also light in shadows, and that other colors were present in shadows, not just the dark brown *asphalt* color that had been used to represent them until then. It is about these other colors that we are going to speak now.

137

The Color of Shadows

The Color of Objects

The color of objects is determined by:

> **Local color**
> **Tonal color**
> **Atmospheric color**

And these factors are, in turn, conditioned by:

> **The color of the light itself**
> **The intensity of the light**
> **Local atmosphere**

Local Color is the color of the objects themselves in those parts not modified by the effects of light, shade, or reflected colors. In Figure 138 on this page, we can see a red polyhedron or multisided figure, in which there are various different tones. The face labeled A corresponds to local color not altered or affected by intensities of light or reflections from the yellow screen.

Tonal Color is the color modified by the effects of light and shade, as we can see in the same figure. The faces labeled B and C receive more light than A, and the color here is a lighter red, while the side labeled D, in the shade, is of a darker color. Now look at Figure 139, in which the polyhedron and the screen receive a weaker light: The red and yellow take on a bluish tone.

Atmospheric Color is created by the colors reflected by other objects and by the color of the light itself, which may be more or less orange or more or less blue in tone. Local atmosphere also affects atmospheric color, toning down and graying the objects farthest away from the viewer, as we can see in Figure 140.

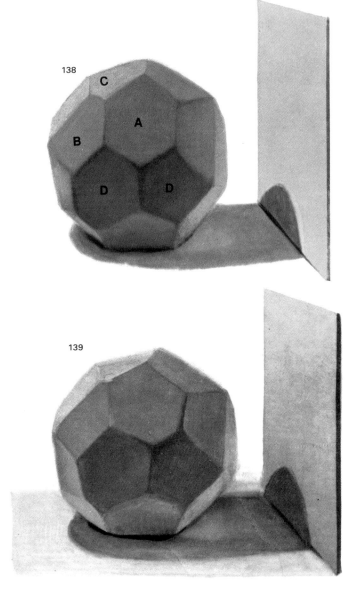

138

139

140

Figs. 138 to 140. The color of this polyhedron, or many-sided figure, is basically red. But this is only its local color, its true color (Fig. 138). There are also reflected color and environmental color, determined by distance and atmosphere.

Complementary Colors

If you project three beams of light—one red, one green, and one blue—you will make white light. If you turn off the blue beam, the red and green lights remaining will give you yellow. Blue, therefore, is a complementary color of yellow, and vice versa (Fig. 141A). In the same way, purple is a complementary color of green, as cyan blue is of red, and vice versa (Fig. 141B). In the following illustration, 141C, there is a color wheel showing the primary colors (P), the secondary colors (S), and the tertiary colors (T). Complementary primary and secondary colors are marked by arrows. Maximum color contrast is achieved through juxtaposing complementary colors (Fig. 142). At the beginning of this century, artists began to paint in the style known as "les Fauves" ("the beasts") because of the brightness of color in the work, achieving their high-impact color combinations partly by juxtaposing complementary colors. Mixing two complementary colors (purple and green) gives black (Fig. 141D), but if we mix them in unequal proportions, adding white, we make a range of broken colors.

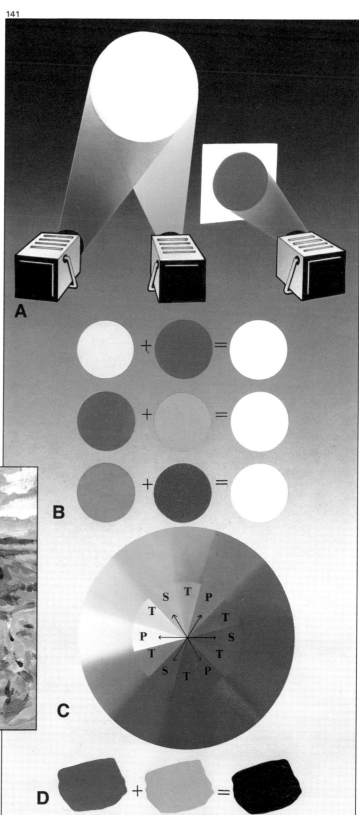

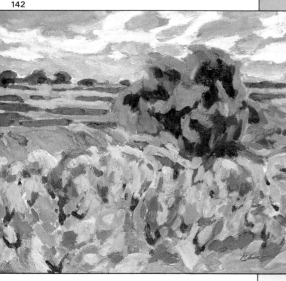

Fig. 141. To speak of the colors of shadows, it is necessary to know something of color theory and particularly about complementary colors, summarized in this illustration.

Fig. 142. Teresa Llacer, *Landscape*. Private collection. Llacer is a great lover of the juxtaposition of complementary colors.

The First Color of Shadows: Blue

Rembrandt, "the master of chiaroscuro," declared quite rightly that *it does not matter what color the light is as long as the shadows are painted in the color corresponding to each light*. Well, as Rembrandt says, you can paint the *local* colors (the true color of the object) of these apples and these orange-colored pottery pieces (Fig. 143) in darker or lighter tones of red or yellow. But what you cannot vary and what must bear a *perfect color relation* to the objects themselves is the color of the shadows. From now on, when you come to paint the color of shadows, so difficult to pin down, do not merely darken them. Remember that:

There is a mixture of colors in all shadows.

143

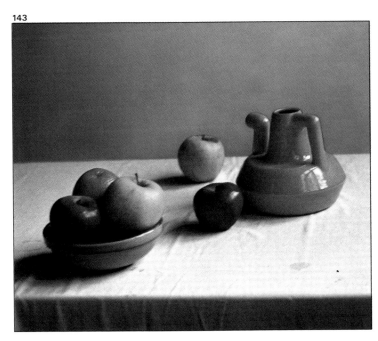

144

True Color or Local Color in a Darker Tone

All shadows contain: Blue, which exists in all areas of darkness; the local color in a darker tone; and the complementary color, in each case, of the local color. I painted the model in Figure 143 *using only the color blue* (Fig. 144). Next I used local color for the parts in light, but painted the shadows *in a darker tone of the local color* (Fig. 145). On the next page, I have painted the shadows using the *complementary colors of the local colors* (Fig. 146). Look at the definitive picture, Figure 147 on page 71, in which I mixed the three colors mentioned above to paint the shadows.

The First Color of Shadow: Blue

When light fades, intensity of color also diminishes, but a weak light with little intensity also creates a bluish light, im-

buing a blue tone into all the colors. Think of the colors of a landscape at dusk; all the colors seem to contain a certain amount of blue. And what is shadow if not an area in which there is diminished intensity of light? In Figure 144, note the quantity of blue that makes up the shadow.

Added Color: A Darker Shade of the True Color

True or local color is what we call the original color, the yellow and red of these apples, the dark yellow of the pottery pieces. This *darker* color is the carmine of the pottery and the red apples, the red in the yellow apples and the sienna in the orange. Study how this formula has been applied in Figure 145.

Figs. 143 and 144 (opposite). Above is the model I used to paint this experiment. Below is the picture reproduced in blue, the first color of the mixture used to create the colors of the shadows.

Fig. 145. Here is the same model painted normally, with the true colors for the light areas, and with the same colors in darker tones for the areas in shadow.

145

The Complement of the Local Color

146

The Color of the Impressionists: The Complement of the Local Color

The complementary color of yellow is dark blue; that of carmine, green; of orange, blue; and so on, mixed with the appropriate local colors. When you paint the true shadow on the crown of a tree, you mix carmine and green and see a perfect color relation between the parts in light and those in shade. In the same landscape, you paint the earthy color of a sunlit path white, ochre, and carmine, making a light ochre-carmine. For the shadows cast by the trees, you make a darker mixture of ochre and carmine, with less white, to which you add a medium tone of blue (blue and white), the complement of ochre-carmine, achieving the perfect tone for your shadows—or at least, nearly perfect.

You then just have to compare this tone with the color of your model, correcting it with a little carmine, or ochre, or white. Of course, the formula I am giving you is not mathematically perfect, because the blue and the darker tone of the local color and its complement can vary in intensity and tone, leaning toward one hue or another. Nevertheless, the formula is valid if you practice with it, try it out, accept without argument that there is a bluish tendency in all shadows. As Vincent van Gogh, said, "I see the color blue in all shadows."

Fig. 146. The complementary color of the true color forms part of the color of shadows. Here dark blue, the complement of yellow, is in the shadows of the pottery pieces, while green, the complement of red, is used in the apples.

True Color in the Finished Picture

147

The Finished Picture

Although the reproduction of a picture is almost never perfect, in this example you can appreciate the presence of the colors or tendencies we spoke of earlier. Note, for instance, the red apple overlapping the yellow jug; by mixing this carminetoned shade of red with blue and green, *with no black*, I have achieved an intense tone that harmonizes with, and gives an accurate relation between, the colors of light and shade. If we add a light but visible touch of green, the shadow becomes all the more "real." This same effect can be seen in the yellow apples, also impregnated with the violet-blue tone in the light reflected by the white of the tablecloth and the red of the apple. These are touches of color that you can create from the application of the formula—blue, a darker tone of local color, plus the complementary color—when painting the color of shadows.

Fig. 147. We create the color of shadows by mixing these three colors: blue, which is present in the colors of all shadows; a darker tone of the true color; and its complement.

We are now entering the territory of practical application. Light can reveal and express. Lateral front lighting reveals the form of a model better than backlighting; diffused lighting from above is more appropriate for the portrait of a woman or a child than direct lighting. Direct lighting might well be chosen by the artist for a self-portrait. Light from below is often suitable, as Edgar Degas and Henri de Toulouse-Lautrec found, for painting dancers, singers, or actresses on stage, or to dramatize a theme, as Goya did in his painting *Executions on May Third*. Badly constructed contrasts can ruin a painting or drawing, and the representation of atmosphere or space between the foreground and the background can give true artistic quality to a picture. All this will be considered in this chapter on the practical application of the effects of light and shade.

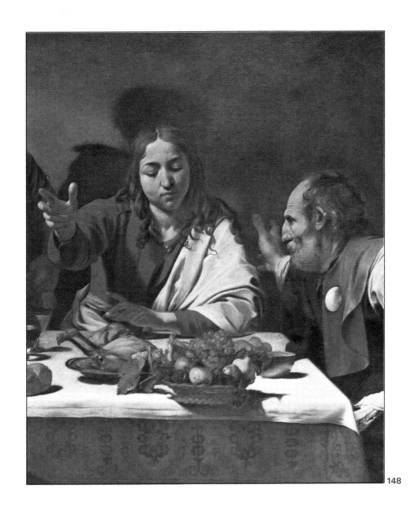

148

Application of General Principles

Theme and Direction of Light

Front lighting or diffused lighting?
In both classical and modern art, you will find many examples of gentle lighting without vivid contrasts, somewhat reminiscent of the features of front lighting. Almost all the Virgins painted by the artists of the Renaissance are lighted in this way. In modern times, Renoir, for example, painted many of his figures with this delicate, often imperceptible, shading, which allowed him to make his colors glow.

No, it is not front lighting exactly, but diffused lighting. Light entering the studio through large windows is one example, or sunlight softened by clouds. Diffused lighting reaches all over the model, bringing out volume but softening contrast, the transition from light to shade. All the great portrait artists throughout history have used this

type of lighting; you can see it in the Madonnas of Raphael, in the nudes and female portraits of Ingres, in the princesses and queens of Velázquez and Goya, in the children and youths of Renoir. Did you notice? Virgins, women, children, youths . . . *purity, spirituality, delicacy, tenderness, softness*: These are the qualities expressed by diffused lighting.

Diffused lighting is also a vehicle for expressing sadness, desolation, melancholy, all the moods of static dramatic sentiment, generally full of spirituality and grandeur. It is the light of the desolate landscape without either shadow or sun; that of the covered sky over the country or city. Diffused lighting is used for many pictures of back streets and suburbs, of ports, river mouths, and railway stations, where the cranes and

Fig. 148 (previous page). Caravaggio, *The Supper at Emmaus* (detail). National Gallery, London. This painting is a clear example of the use of light and shade as a means of expression.

Fig. 149. Claude Monet, *Interior of the Saint-Lazare Station, Paris*. Orsay Museum, Paris. Here there appears to exist diffused front lighting, without a firm definition of highlights or shadows.

149

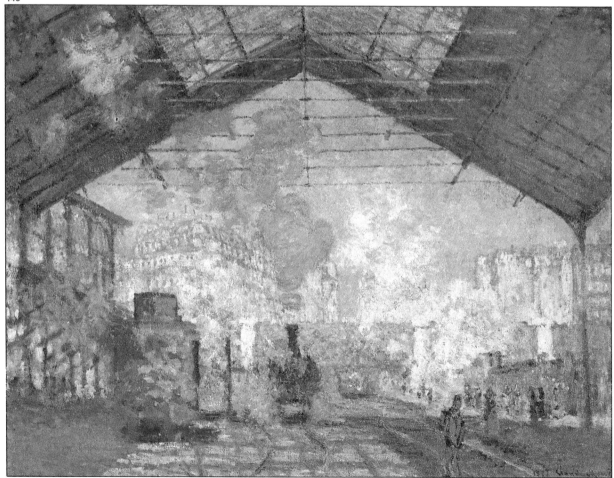

150

151

152

machinery are gray. In these cases, the artist uses atmospheric feeling to portray depth, graying the background, adding gray- and blue-colored air between this and the foreground.

Figs. 150 to 152. Veláz-quez, *The Infanta Margareta Teresa at the Age of Four* (detail) (Fig. 150); David, *Madame de Seriziat* (Fig. 151); both in the Louvre Museum, Paris; and (Fig. 152) Berthe Morisot, *The Cradle*, Orsay Museum, Paris. Velázquez painted in the seventeenth century, David in the eigh- teenth, and Morisot in the nineteenth. All three painted figures in their own personal style, but they painted with front or diffused lighting, a type of light that illuminates the whole model gently, almost sweetly. This choice of lighting is in harmony with the themes: a little princess, an elegant lady, and a mother.

Colorist Front Lighting

The Postimpressionists and the Fauves created the colorist technique, a style of painting in which volume expressed through shadow is practically nonexistent. An example of this style is reproduced here in the picture by Serusier.

Many modern artists, in their desire to paint "only light," drew and painted many of their works using front lighting. Claude Manet, Vincent van Gogh, Henri Matisse, Amedeo Modigliani, and Maurice Utrillo, to mention just a few of the most illustrious names associated with this style, painted with truly *flat colors*. Manet, with his famous painting *The Piper*, introduced this tendency into

153

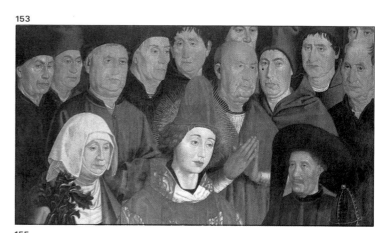

155

154

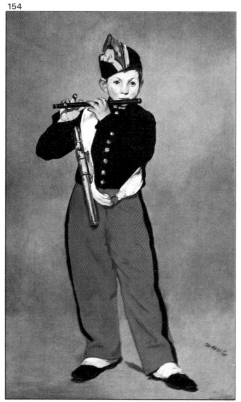

the world of art. This is a portrait in which color dominates in an almost total absence of shadows.

We could say, then, that direct front lighting, without shadow, is associated with ideas of modern, decorative art.

Fig. 153. Nuno Gon-çalves, *The Portuguese Royal Family Venerating Saint Vincent* (detail). National Art Museum, Lisbon. The Portuguese artist Gonçalves painted this superb fifteenth-century work as if he were a modern *Postimpressionist*.

Fig. 154. Edouard Manet, *The Piper*. Orsay Museum, Paris. With this painting Manet began the idea of using flat colors, without shadows.

Fig. 155. Paul Serusier, *Landscape. The Wood of Love*. Orsay Museum, Paris. This is an example of a picture painted with a modern colorist vision.

Lateral Front Lighting

The Most Frequently Used Type of Lighting

This is the most appropriate form of lighting for *revealing* the form of things, giving an ideal sensation of volume and depth, as we said in the previous chapter. Lateral front lighting reveals physical features better than any other form of lighting: the shape of the nose, whether it is long or short, snubbed or aquiline; the depth of the wrinkles of the face; the form of the cheek bones. Lateral front lighting brings out the volume of an apple, a figure, or a house.

This type of lighting can be seen in most masterpieces depicting figures—in the works of Rubens, for instance, perhaps the greatest artist in the rendering of volume. You will see it in an infinity of still-life paintings, because the still life is almost always a demonstration of how to represent three dimensions while working in only two. You will also find lateral front lighting in landscapes, in drawings of animals or flowers, and in all other types of paintings and drawings. Lateral front lighting is often used to bring out the character and virility in a face, as can be seen through study of the figures and portraits of classical painters. As shown earlier, in his drawings and paintings of women, Ingres used to light the face with diffused frontal lighting, in this way portraying a softer, more feminine face. He used the same formula when painting or drawing the portrait of a young person, though with a slightly more direct, harsher lighting. However, when it came to modeling the face of a grown man, he opted for lateral front lighting, strengthening shadow, revealing wrinkles, the shape of the nose and jaw, giving the picture a more vigorous, masculine air. This is general practice in classical and modern portraiture.

But, above all, lateral front lighting *serves as a vehicle of expression for the theme*. It has a completely documentary quality, intending to show the subject as fully as possible.

Figs. 156 to 158. Velázquez, *The Topers* (detail), *Baltasar Carlos in Hunting Costume*, and *Portrait of a Young Man* (considered to be a self portrait). All in Prado Museum, Madrid. The first is a classic example of lateral front lighting, bringing out form and accentuating volume. The two portraits show Velázquez painting the head of a child with, practically front lighting and his self-portrait with a type of lighting much more to the side, hardening the modeling and the character of his face.

156

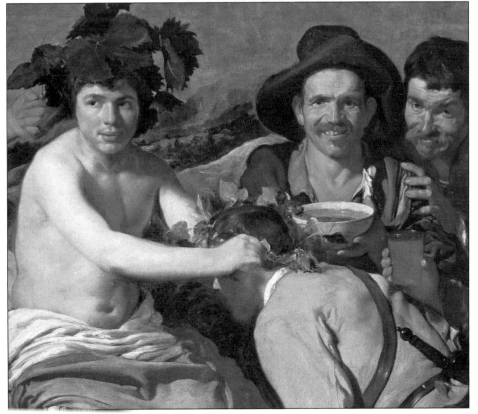

157

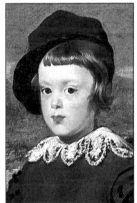

158

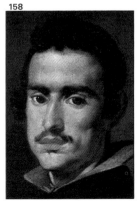

Valuist Side Lighting

As more shadows are added to the model, the dramatic effect is strengthened. This is the case with side lighting, when light reaches the model from one side or another, so that one half is in the light and the other in shade.

Perhaps because one half is illuminated and the other is in shadow, *totally* lateral lighting is used little in drawing and painting. You can see it, however, in some masculine portraits, in some dark-toned still lifes, and in drawings and paintings of interior views.

What is common, though, is partially lateral lighting. This renders the plasticity of the lighted half and the dramatic effect of the dark half, with its large shaded areas—a perfect combination for revealing volume while at the same time expressing feelings, moods, and even passions.

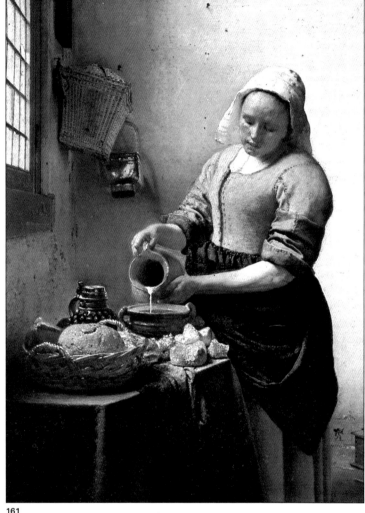

159

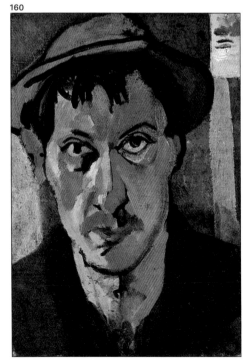

160

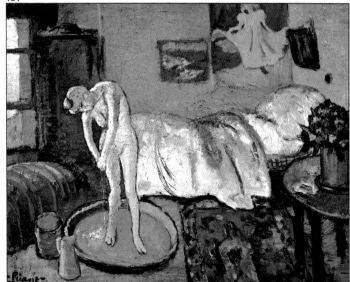

161

Backlighting and Semi-backlighting

Lighting for a Poetic Effect

Backlighting always presupposes the existence of two lights: one strong, direct light shining on the model from behind, and an atmospheric light, weaker than the first, which shines on the model from the front and permits us to see and draw its forms. Without the latter we would be able to draw only silhouettes.

The first of these lights produces the characteristic halo of light around the model, a luminous border bringing out the contours of its forms.

Remember to put a strong, direct light behind the model, backlighting it, and a second light in front of the model. The weaker light acts similarly to a screen or atmospheric light that reflects some light into the shadows, making them weaker. (Refer back to page 23.) In sunlight, for instance, the sun lights the model from behind, and also shines directly at the artist. Direct sunlight highlights the outer contours of the model and leaves the rest in shade, but even the shaded areas can be seen thanks to atmospheric or reflected light.

Obviously, inside a room, atmospheric light is not enough to bring out the forms in shadow. In this case, we may really need a second light, for which purpose we can use a window or a reflecting screen.

However this may be, backlighting gives a poetic effect. A painting seems like dramatic poetry when the atmospheric light is weaker, narrative poetry when there is a balance between the intensity of the atmospheric light and that of the direct lighting shining on the model from behind, and lyrical poetry when the atmospheric lighting is intense and all the forms take on a magical quality.

The basic features of backlighting as an element of expression can be defined as transparency, youthfulness, fragrance, and freshness. The special way in which forms are modeled using this form of lighting accentuates the feeling of depth, particularly when painting outdoors.

Fig. 159 (Opposite, above). Jan Vermer de Delft, *The Kitchen Maid*. Rijkmuseum. Amsterdam.

Fig. 160 (Opposite, left). André Derain, *Self Portrait with Hat*. Mr. and Mrs. Nathan Smooke Collection, Los Ángeles.

Fig. 161 (Opposite, below). Pablo Picasso, *The Blue Room*. Phillips Collection, Washington.

Fig. 162. Joaquin Sorolla, *A Beach in Valencia*. Private collection, Madrid.

Fig. 163. Pierre-Auguste Renoir, *The Reader*. Quay d'Orsay Museum, Paris.

162

163

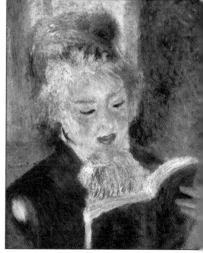

Lighting from Above and Zenithal Lighting

Lighting from Above

Lighting from directly overhead is used only in special cases, when we are attempting to capture images of powerful effect, generally themes concerning the supernatural. This is the light that "comes from the Heavens," shining on the saints and apostles painted by the classical painters in a masterful combination of theme, background, and distribution of areas in light and shade.

Lighting from above often creates a funereal, somber effect. It is associated with the representation of eternity, of death, and of God.

So far I am referring to lighting from directly above, almost vertical. Oblique lighting—between frontal and vertical—is commonly used both in open-air themes and in studio works. This type of lighting, by the way, has a name:

Zenithal Lighting

Zenithal lighting is diffused light from above (from the zenith), light shining through a high window, for example. It is to be seen in many paintings and draw-

ings of the studios of classical artists, and I myself have seen it in the workshops of fine arts schools. A classic example is reproduced on this page, the curious version of an artist's studio painted in the seventeenth century by Adrien van Ostade. In this drawing, note how a light-colored cloth has been placed on the ceiling to reflect the light entering through the window downward, in order to produce the zenithal lighting we are speaking of, and the position of the wooden boards perpendicular to the window, another aid to the same effect.

The expressive capacity and possibilities offered by zenithal lighting are comparable to those of diffused front lighting.

Fig. 164. Adrien van Ostade, *The Artist's Studio*. Light reaches the painter through a window, with a type of screen above it and a cloth on the ceiling that also reflects light.

Fig. 165. José M. Parramón, *Urban Landscape*. Private collection.

Fig. 166. José M. Parramón, *Composition with Fruits*. Private collection.

Fig. 167. José M. Parramón, *Portrait of Marta*. Private collection.

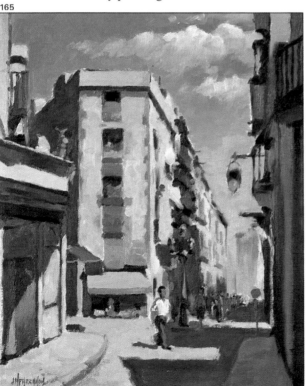

Lighting from Below

Lighting from Below

This is generally used to express terror or mystery. This is the lighting of suspense, of horror films. A typical example would be the famous painting by Goya, *Executions on May Third*, in which the artist deliberately places a large lantern on the ground, lighting the scene from below and by this means expressing more forcefully the commotion and panic of the condemned prisoners. (This painting is reproduced in Fig. 30, on page 20). But lighting from below can also be employed in the creation of a magical or supernatural atmosphere, as in the religious painting by El Greco reproduced on this page.

Don't think that these ideas are absolute and unchanging. No, in this and all types of lighting, a different interpretation from the one generally applied is always possible. For instance, there are the famous works of Degas depicting dancers, musicians, singers, and stages, illuminated from below by the light of candles, but by no means with the intention of expressing fear or some miraculous event.

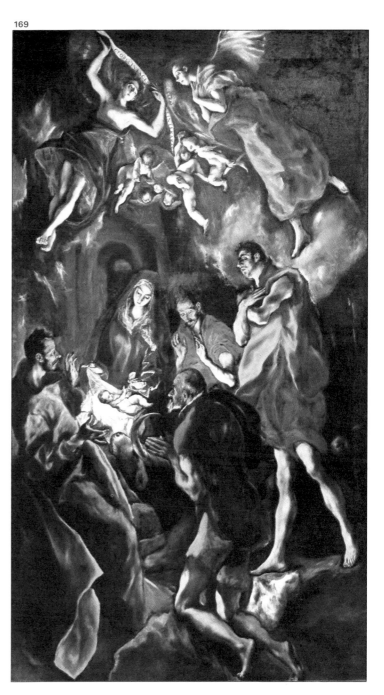

Fig. 168. Edgar Degas, *The Café Concert*. Saint Pierre Museum, Lyons. The light comes from below, in this case because of the stage lights. This theme and form of lighting were used very often by Degas.

Fig. 169. El Greco, *The Adoration of the Shepherds*. Prado Museum, Madrid. A magical, supernatural light, very much a staged lighting, is appropriate for this theme. El Greco composed his pictures with models but also used mannequins, which he placed in seated or standing position, or hanging from the ceiling, as in this case with the figures of the angels and cherubim.

Quantity and Quality of Light

The general principles outlined on the preceding pages are all subject to the quantity and quality of light as well as to its direction. Quality is given basically by direct or diffused lighting, producing stronger or more gentle contrasts, respectively, force or gentleness, passion or balance, and so on. Quantity, on the other hand, the presence of a greater or lesser amount of illumination, helps to express actions, ideas, or emotions associated with light or with darkness.

In any case, it is important for you to choose your type of lighting according to what the model is or represents, as well as what you wish to express in your drawing or painting.

It is usual to draw with two or more sources of light?
Basically, no. Draftsmen or painters are not like photographers, who model their figures using artificial lighting, with any number of lamps and reflectors distributed around the studio. We artists normally work with daylight, because this type of light—with its highly diffused quality, its intensity and its color—is practically impossible to imitate by any artificial light source. Daylight gives us a constant, true reference to color because it is *natural* light, which is best retained in our eyes and memory, and which is the most easily associated with reality.

Furthermore, unlike photographers, we artists can modify and adapt the effects of daylight to our needs. We can accentuate, soften, or improve contrast by blending, darkening, or making lighter at will.

170

171

Figs. 170 and 171. Felipe Santamans, *Still Life with Painting Materials*, and *Nude*. Private collection. Santamans is an excellent painter in pastels, using a warm, friendly language achieved through a softened zenithal lighting in which he occasionally incorporates a complementary lighting, illuminating the parts in shadow to create gentle reflections and to explain form in more detail.

In any case, when we are drawing or painting outdoors there is no choice to be made regarding numbers of sources of light. There is just one single indivisible light source at our disposal.

It is different when we are working in the studio, in a room that receives light from outside through openings, windows, or doors, which may be large or small. When painting or drawing a still life

172

173

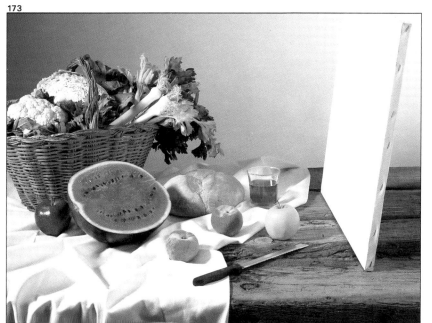

composition of fruit, for example, using diffused lateral front lighting, you may see that the areas in shadow are too dark and think to yourself, "How about a light there, to take away those shadows?" Yes, why not? And what type of light? That of an artificial lamp? Well . . . no, *you would be well advised not to, because you would alter the coloring, producing a yellowish reflection in the shadows, a color different from that of natural lighting.*

The best thing here is to use a white reflecting screen.

The Reflecting Screen as Second, or Complementary, Light Source

When you need to eliminate shadows when working in the studio—to accentuate the light reflected in a portrait, figure, or still life—it is worth considering the possibility of a reflecting screen. For example, use a frame with a white canvas, a sheet or piece of white cloth, or just an ordinary sheet of white paper, but it must always be white. Be careful where you place it, whether nearer to or farther away from your model, wholly reflecting the white light or just partially, and at what angle. Pay special attention to the fact that your screen must constitute an additional form of lighting, a means of strengthening and improving modeling, volume, and depth, but must never weaken the basic light, producing exaggerated reflections in the model. Never use two equal types of lighting or even two lights of similar intensity, for the one will cancel out the effects of the other, and the natural, artistic quality will be replaced by artificiality.

Figs. 172 and 173. In the still life in Fig. 173, I have used a reflecting screen to create reflected light, softening contrast and modeling the forms better. It is quite common to use these screens, and is recommended as long as there is not too much reflected light. As Ingres said, reflected light should "not destroy the form through excessive presence."

Contrast and atmosphere are the two basic factors in the representation of the third dimension. Contrast combined with valuing allows us to represent volume; atmosphere combined with contrast provides us with the means of expressing depth, the space between the foreground and the background. Furthermore, contrast, when combined with the direction and quality of light, allows the artist to express ideas or emotions, such as *strength* or *weakness*, *war* or *peace*, *passion* or *ecstasy*. Contrast may also be *simultaneous* in order to bring out a tone or color. It can be dramatic or gentle and can be used to highlight forms and contours in the background. Extraordinary artistic quality can be attained through the definition and contrast of the foreground combined with an atmospheric representation of the background and middle ground, using blurred forms and outlines, ''out of focus.'' We are going to look at contrast and atmosphere in this chapter, where we will see how important it is to understand them in order to improve our drawing and painting.

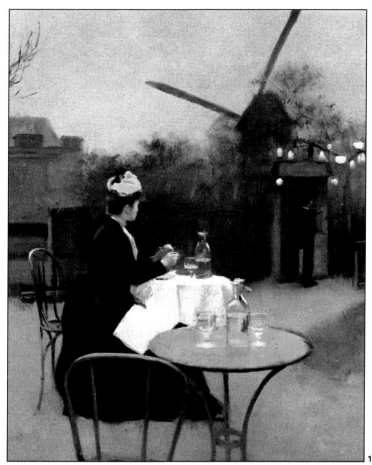

174

Contrast
and
Atmosphere

Contrast

The first factor to be dealt with when drawing light is *value*, which gives us the tone. Then comes *contrast*, which, combined with the first, gives us *volume*. Because contrast is the effect produced by comparison of two or more different tonalities, we can affirm that "there is no contrast where there is no color, when the work is exclusively linear."

Moreover, since we know that black and white are the opposite poles of any range of tonalities, we can also state that "maximum contrast is achieved when a drawing is exclusively in black and white."

Between these two ideas are to be found all the possible effects of contrast: gentle contrast, hardly perceptible, based on a scale of high luminosity; an academic contrast employing dark black, dark gray, medium gray, and so on until we get to pure white; and a hard, strong contrast approaching maximum contrast, in which intermediate tones are scarcely present and there is a predomination of light opposed to dark.

175

176

Fig. 174. Ramón Casas, *Full Air*. Modern Art Museum, Barcelona.

Figs. 175 and 176. Albert Marquet, *The New Bridge*. National Gallery of Art, Washington, D.C. Chester Dalle Collection. The Impressionist painter Marquet's use of light is illustrated here in this free interpretation of an urban theme, seen with backlighting and extraordinary contrast (Fig. 176). This same theme can be represented in a linear drawing, as you can see in Fig. 175, but in this case there is no contrast, because of the absence of tones and colors.

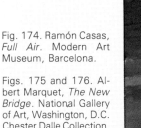

Simultaneous Contrast

If you take two sheets of white paper and place them next to each other, painting one of them black but reserving a small white space in the center, you will note a strange physiological effect: White, when surrounded by black, is *whiter* than the white of a sheet that has not been painted. If you paint an ocher form onto the center of a white sheet of paper, and the same ocher against a black background, you will see that the latter appears much less dark than the former. Make a mental note of the results of these two experiments in simultaneous contrast:

1. The darker the background surrounding it, the whiter a white appears.

2. The lighter the background surrounding it, the darker a gray appears.

Let us apply these principles to practice, first in solving a common problem faced by the beginner: the problem of whites.

Figs. 177 to 180. According to the law of simultaneous contrasts, the yellow ocher square appears darker against the black background than against the white background, even though exactly the same ocher color is used in both. The same occurs with the silhouette of *The Three Graces* by Rubens, printed in flesh color against a white background and a black background.

177

178

179

180

The Problem of Whites

I promised my friend Ramón a portrait, and here he is, a little old man quietly seated, looking like a saint of old.

I've chosen clear, diffused lighting, a little above and almost frontal, to capture this serene saintliness. Behind him I will use a light gray background, for this seems to sum him up—clarity that has been a little diminished by the passing of the years.

I draw, outlining shadows, studying contrast to render the tone of the background . . . and, little by little, as if the clearness of his face were whispering to me, *I gradually raise the light gray of the background until it is a darker gray, . . . darker and darker until . . .* Enough! Through simultaneous contrast, Ramón's face has taken on its characteristic paleness.

To continue, I have decided on a half-body portrait of my friend. There, on his left wrist, below the edge of his shirt cuff, is the wristwatch given to him by his grandchildren last year, a gold watch. And here we have our problem, the problem of whites. On the one hand there is the shirt cuff, which at first glance you would say was white—and it is. On the other hand, there are the highlights of the gold watch, and those sparkling gleams coming off the glass, like little lights, really giving off light. Well,

if the cuff is white, what white can I use to represent the tiny lights of the sparkling watch?

Leaving friend Ramón for a moment, do you know the theory of the two whites of the model? Well, it is based on a fact that few beginners bear in mind and that I am going to set down here in bold print to help you to remember it:

No object is absolutely white:

The white on large or small patches of a surface, such as the cuff of Ramón's shirt, does not exist; or, better, it is not a *white* white. Absolute white is light, and this we can see only in such areas as the watch, where it appears as highlights and flashes of light. So, generally speaking, this shirt cuff should be painted a slightly dirty white, white with a little gray . . . though we can also put in a gentle highlight, a whiter area, at the maximum point of light.

Try to remember this important lesson. Think, whenever you see a white patch in your model, that in theory and in practice, there are two whites: one white that is less white, with the tiniest touch of gray, and a pure white, that of the paper, which *exists only in the highlights.*

Fig. 181 (below). Values of tones and contrast between values are two fundamental aspects of both drawing and painting. (It is easier to work with values and contrasts when painting if you master them in drawing first.) This drawing is an example of the problem of the whites. As you can see, the cuff of the white shirt has been given a very light gray; no object is pure white. The absolute white of the paper is reserved for the highlights of the glass and frame of the watch.

Figs. 182 and 183 (opposite page). You should never draw a model on a light background, adjust the model's values against this background, and then darken the background. If you do, the law of successive contrasts will mean that your model's values will lose intenstiy, as you can see in these figures. And the same applies the other way around. If you suddenly lighten the background, your model's values will become too dark.

181

Remember, too, that to brighten the dirty white you can lie a little in the dark tones surrounding it—that is, you can make them a little bit darker.

(We have finished. Thank you, Ramón). Now I will go on to another experiment in simultaneous contrast, one that ended in a failure for me which I will never forget.

It was at art school, drawing in charcoal. I spent, I suppose, about fifteen or twenty days working on a drawing of a plaster statue of Caesar Augustus, a full-body Greek sculpture. Can you imagine? Hours and hours slaving away, a bit more here, and how can I draw this, and my outline is wrong here, and so on.

I drew it on a white background, using the white of the paper itself. I thought it looked pretty good.

But a row or two in front of me was someone working on a drawing of Minerva, the goddess Athena, also full-body, also from a plaster statue . . . and he was drawing it on a black background.

And I looked at my Caesar, and, well, it was all right, but that Minerva seemed to leap off the paper! And all there was to it was to draw on a black background! I discussed this with my fellow students—unfortunately, not with my teacher—and did it.

Horrible! I can still remember: My Caesar looked tiny and weak, without contrast, incredibly low in tone. I got red in the face as I bungled on with my charcoal, reinforcing here, darkening there . . . "So many hours! So many hours! Such hard work!"

I slashed a great charcoal X on my drawing and left.

I will never forget that moment.

The lesson is this: "The lighter the background surrounding it, the darker a gray appears." That is what happened with my Caesar after I made my background black.

And the consequence is that tonal balance is intimately related to contrast. You cannot deal with these two aspects separately, but have to work on them together, at the same time.

Theme and Background

It is important to remember that contrast has to be planned even before you begin to draw, when you are studying the position of the model, your point of view of the model, and the type of lighting to be employed. Leonardo wrote on this subject that:

"The background surrounding a figure must present darkness behind the illuminated part of the figure and lightness behind the part in shadow."

Look again at the photograph of the Venus de Milo on this page, taken with front lighting, a clear example of this rule. Note that the right-hand side of the figure, the part in shadow, is over the lighter part of the background, while the left-hand side, the side in the light, stands out strongly against the darkness of the background behind it. The juxtaposition of dark on light and light on dark is not coincidence; it is a deliberately studied effect to highlight the figure more.

With the same idea in mind, the painter Sunyer, in his picture *Mother and Child* (Fig. 185), darkened the background on the left-hand side, where the head, shoulder, and arm of the figure are in the light. Note, also, that on the same side, at the top, the background is a shade lighter, highlighting the dark contours of the hair.

The background of the self-portrait of the artist Sanvicens (Fig. 186 on the next page) responds to the same idea, but with a different solution. Sanvicens, who adopts a fauve style of painting in some of his work, divides the background, using two plain colors, a slightly dirty white in the left and a bright red in the right. This gives a strong highlighting of the side we could say is in shadow (painted green, complement of carmine-red-orange). The decorative chromatic stridency is maintained in the right-hand side, but this does not totally eliminate the highlighting of the head on this side. Look now at the two illustrations that follow, examples of what to do and what not to do. Both still lifes are in lateral

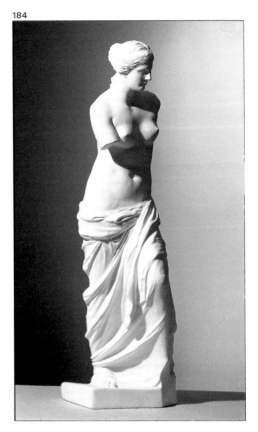

184

Fig. 184. To make the figure of the Venus de Milo stand out, we have used a gradated light in the background: dark on the left and light on the right, so that the dark background is behind the lighted side of the model, and the lighter area of the background is behind the part of the model that is in shade.

Fig. 185. This idea of altering the lighting of the background according to the effects of light and shade in the model is common practice with many artists, such as Joaquin Sunyer, who uses this technique in this picture *Mother and Child*, exhibited in the Catalonia Art Museum, Barcelona.

185

186

front lighting—more side lighting than lateral front lighting, in fact—but while the lighting in the first is simple, in the second, efforts have been made to provoke contrast of the tones showing the limits of the essential forms, so that volume and the model are more clearly brought out. In this second case, a reflecting screen was used, directed toward the background, making lighter those parts of it that were in shade.

Fig. 186. Sanvicens, *Self-Portrait*. Private collection. In this picture, the artist has used two flat colors, red and a dirty white, in his background. The latter color coincides with the profile of the head, which is made to stand out through contrast with the background. The Fauve chromatic style is accentuated by the red of the right-hand side of the background, though the form of the head on this side is by no means lost here either.

Figs. 187 and 188. Let these illustrations help you remember that with certain models it is a good idea to use a second, or complementary, source of light, in order to create greater effects of reflected light. This technique makes the background lighter by highlighting the dark, shaded profiles of the model and revealing more of the dark areas of the picture, creating chiaroscuro, or light in shade.

187

188

Provoked Contrasts

Provoking contrasts is done by astutely softening tones next to darker patches so that these stand out more strongly, or darkening patches next to lighter tones, so that these are more brilliant, increasing contrast. The trick of using provoked contrasts is to be seen in the work of all the great artists. Through the analysis of edges and contours, you will often find a type of halo, a patch of luminosity, or an almost imperceptible touch of a darker tone next to a light color, highlighting and bringing out the contrast of form, volume, and depth. In the work of El Greco, for example, the audacity of his provoked contrasts is often surprising, but you can be sure that the viewer, you yourself, will not notice them. In modern art, this element is much easier to see, becoming part of the style. In the work of Degas, we can occasionally see concrete lines limiting and separating tones, and Cézanne darkened or made lighter the backgrounds of his contours with the single objective of contrasting and bringing out colors and forms.

The effect produced by provoked contrasts can be studied in the picture by Sunyer in Figure 185 on page 90, in the still life by Cézanne at the bottom of this page, and in the reproduction of *The Resurrection* by El Greco on the next page. To make things easier to understand, I have drawn diagrams next to each of these last two paintings, in which red arrows mark the points where the artists highlighted forms through false, or provoked, contrast.

From now on, whenever you accentuate parts of your work, provoking contrasts of limits and forms, bear in mind that you are beginning to create your own style, imbuing your own unique personality and temperament into your painting and drawing.

Figs. 189 and 189A. The trick of using provoked contrasts can be seen in the work of many painters, and may escape the notice of inexperienced artists. In Fig. 189A, there are a number of red arrows marking the areas in which Paul Cézanne, with different degrees of intensity, has highlighted the profile or contour of forms by darkening the object or background element next to them.

189A

189

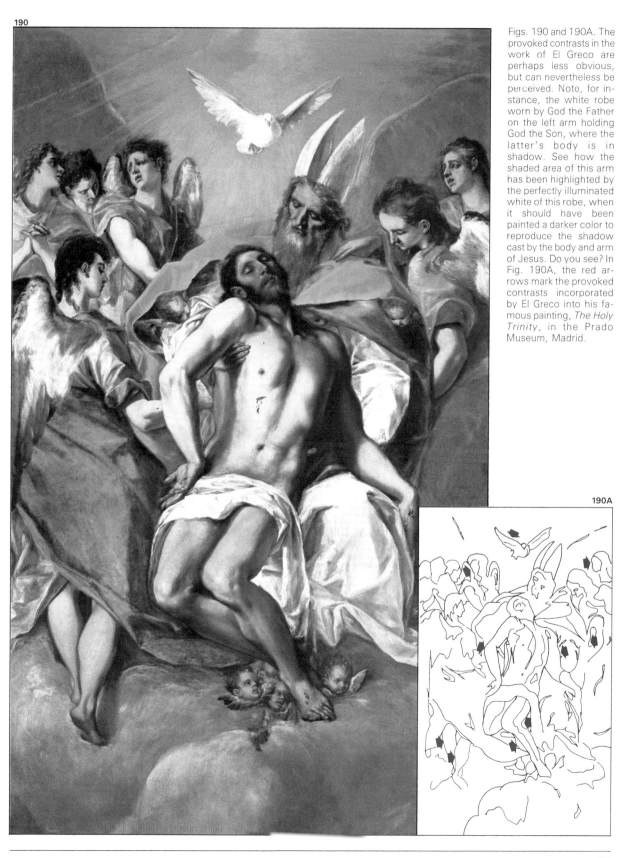

190

190A

Figs. 190 and 190A. The provoked contrasts in the work of El Greco are perhaps less obvious, but can nevertheless be perceived. Note, for instance, the white robe worn by God the Father on the left arm holding God the Son, where the latter's body is in shadow. See how the shaded area of this arm has been highlighted by the perfectly illuminated white of this robe, when it should have been painted a darker color to reproduce the shadow cast by the body and arm of Jesus. Do you see? In Fig. 190A, the red arrows mark the provoked contrasts incorporated by El Greco into his famous painting, *The Holy Trinity*, in the Prado Museum, Madrid.

Atmosphere

Values, contrast, and atmosphere are the three factors that give us depth.

Between the place where you are now, reading this section, and the wall in front of you, there is a space, and in this space there is atmosphere. The question is how to represent this atmosphere in your work, to remember that it is there and to simulate it, since its appearance will vary according to the circumstances.

An Example of Visible Atmosphere

In any seaport, early in the morning on a cloudy day, you can observe the effect of interposing atmosphere. At times like this, there is usually a little mist that tells us the distance between one thing and another, like curtains of gauze hanging between forms.

Imagine that we are standing on a dock. There, in the foreground, we can see a number of small boats, their forms perfectly delineated, brightly colored, wet,

with strong contrast between light and dark areas. The water sparkles here, with clearly defined crystal highlights resembling shining metal. Fifty yards away is a group of sailboats and small vessels forming a compact mass, unified by the bluish gray. Their masts and sails can still be distinguished, though they do not stand out from the overall setting, as if we saw the whole through a polished glass. There are no bright contours, only hazy edges. And in the background, where the water is now just a colorless stain, there is a building on a dock that really appears to be made out of smoke: It is no more than a large stain of light gray, smoky, with is contours completely blurred. Comparing the intensity of tone of the three grounds and that of the water disappearing into the distance before us, we notice that the colors are fainter the farther away from us they are.

Fig. 191. José M. Parramón, *Seascape with Boats in the Harbor.* Collection of the artist. Here is an example of clearly seen interposed atmosphere, painted early in the morning when the sun is rising. Backlighting produces a golden mist that dilutes and enfolds the forms of the model as they get farther away.

191

The foreground has bright, brilliant tones; the middle ground has medium values; and the background, almost washed away, has a gray tone only slightly darker than the white of the sky.

This visible example allows us to determine those factors that make up the feeling of atmosphere, namely:

Lively contrast between the foreground and the middle and backgrounds

Discoloring and tendency to gray as objects get farther away from us

Notable clarity of form in the foreground, compared to the middle and backgrounds

Learn these factors by heart and apply them to your work. It may be helpful to review this section periodically.

I am insisting on this point because it is perhaps the defect I have seen most often in the drawings and paintings of beginners: lack of atmosphere. Because of this, and because I have never seen a book on drawing or painting that analyzed atmosphere in terms of precisely these three factors, I will now discuss them separately, compiling a definitive lesson from them that I hope you will remember and apply in all your future work.

Fig. 192. José M. Parramón, *The Fishermen's Dock*. Private collection. This quick color sketch was painted in the same place as the drawing on the previous page. It is an example of painting in the three primary colors: lemon yellow, carmine, and Prussian blue, as well as white. It is also an example, in color, of interposed atmosphere. The contrast is accentuated in the boats and reflections in the foreground, while diffused forms and colors are in the middle ground and background. This is an ideal formula for representing depth, or the third dimension, in a picture.

192

Contrast Diminishes as Distance Increases

Ask someone who knows little about drawing and painting this question: "When do you think the color of an object is clearest, when it is near us or when it is farther away?" Almost certainly, the person will answer: "When it is near us," continuing by saying that, in his opinion, we see things that are close to us very well, while we do not see things farther away so clearly. "So things farther away," he will conclude, "are darker than things nearer to us."

Tell him that he is wrong, and show him how that mountain in the distance contains dark bodies, black even (such as tree trunks or blackish earth), despite which from here where we are, *everything appears bluish, rather pale, to us*. This same principle applies to the sea or a broad expanse of farmland or whatever.

"Hey, you're right!" your friend will say to you. "Yes, it's true. The farther away things are, the lighter they become to us." Tell him again that he is wrong, and use this argument: "Look, if you are in the middle of a snowy landscape, you will see very well that while the snow around you is completely white, the snow on the mountaintop appears blue, that is to say, a darker tone than the white you see close to you."

Then put him right by adding that:

> **The foreground is the darkest and is, at the same time, the lightest.**

By this we mean that tones are not lighter or darker in the foreground than in the background, but that *there is greater contrast of tones*. Remember this basic rule for capturing atmosphere:

Contrast diminishes as distance increases.

Put this into practice when you are drawing or painting. When you are working on the foreground, make contrasts as strong as you can. This will depend on your theme and on the type of lighting you are using. Tone them down more and more as you get farther away, working on the middle ground and the background. You will see how the foreground "leaps out at you!" And this is our goal in our study of atmosphere.

Fig. 193. John Pike, *Winter Composition*. Private collection. Variation of contrast and definition of forms in the foreground and background is well illustrated in this beautiful watercolor, published courtesy of Watson-Guptill Publications. Observe the detail and contrast of the foreground, with the trunk half-buried by snow, compared to the lack of definition and contrast in the row of trees and blue mountains in the background.

193

Tone and Atmosphere

And so tone gets weaker and weaker, until it is lost. When you are drawing or painting, say, a row of trees, you will see a bright green tone in the crowns of those nearest to you, a paler green mixed with gray in those a little farther away, and a weak bluish gray in the most distant ones, almost blending into the clear colors of the sky. There is nothing worse than an intense, strongly colored background, coming out of the background and pushing itself into the foreground! It is a thousand times better to exaggerate the sense of distance by using pale gray, atmospheric, tones. Combined with the blacks and whites of the foreground, a muted background invites us to "come into the picture."

Contours and Atmosphere

I would now like you to read this brief but complete lesson by Leonardo in his *Treatise on Painting*, where he speaks of the relationship of contours with atmosphere:

"All those parts of a work that are close to the beholder must be finished with great care, according to the different planes contained in it. The first plane must be finished cleanly and precisely; the second finished in the same way, but more vaporously, more confused, or, better, less precise; and so, successively, according to the distance, the contours become softer and parts, forms, and colors disappear."

Study this effect of atmosphere created by the clarity and the diffusion of the contours in the first picture you have the chance to look at—always assuming that it is by a good painter—and you will see that:

In a landscape, the horizon is never clear. In a scene with many figures, those in the background are never clear.

Fig. 194. George Bellows, *Blue Morning*. National Gallery of Art, Washington, D.C. Here we can admire a magnificent rendering of depth, produced by capturing and exaggerating interposed atmosphere. The buildings in the background, whose forms we can barely distinguish, are a warm grayish blue.

194

When All the Subjects Are in the Foreground

It may be that, without preparation or study of any kind, you are at this moment painting a landscape and capturing all its atmosphere, simply because you are drawing what you see. Perhaps the contrast in the foreground and the lack of clarity and color in the background are really there in the landscape, so that all you have to do is see it and copy it.

A really interesting case, difficult to solve by intuition, is when the model is completely in the foreground and does not offer middle ground or background, or visible atmosphere, at first sight. This could be a still life or an interior drawing, for example.

Let us begin by affirming that in these and in all themes the third dimension exists, so the air interposed between one object and another is also there.

Of course, this type of atmosphere is not so visible as it is outdoors, where contrasts and tones (particularly the latter) are modified by long distances, by huge quantities of oxygen and nitrogen, by atmosphere. But we still have one last factor that is our salvation when it comes to representing depth in these cases: *CLARITY of the images closer to us with respect to those farther away.*

Let us leave atmosphere for a moment and speak of optics and our organs of sight.

No matter how uninterested in photography you are, you know what an *out-of-focus* image is. You also know that it is possible to focus a camera so that it takes an absolutely clear photo of an object in the foreground but leaves another object behind it out of focus and blurred, even if the distance between the two is very short (a foot, say).

The optical system of a camera is, in theoretical terms, the same as our own organs of sight; and I say in theoretical terms because in practice our eyes win by a long shot. Anyway, what I mean to say is that we too focus and leave out of focus. We do this instinctively, so unconsciously that you may never have noticed yourself doing it.

Fig. 195. José M. Parramón, *Still Life with Blue Jar* (detail). Private collection. There is a definition of form in the creases of the white tablecloth and in the two apples in the foreground that does not exist in the peach, the cloth, and the chair of the background. This lack of definition is not exaggerated, but it is visible and strong enough to represent depth in the picture.

195

Try an experiment. Take any object in your hand, something small like a pencil, and hold it in front of yourself at eye level and at a distance that allows you to read the name of the manufacturer and the number on it (about a foot and a half away, more or less).

Now, careful! Look hard at the pencil and then—quickly—look at what is behind it. Now look at the pencil again, then quickly at the background, each time keeping your gaze fixed, without looking away from the pencil, but as if you were looking through it. Do you see? When you look at the background, although the pencil is still in front of your nose, it becomes completely blurred, and when you look at it, the background becomes blurred, out of focus.

Well, all you have to do when painting a still life or a figure with a particular background, or some other theme that does not offer long distances between one ground and another, is to draw or paint it as you would this pencil: defining and making clear the form of the pencil and anything else in the foreground while leaving the rest to a greater or lesser extent out of focus, according to the distance between. You can rest assured that in this way you will capture a lifelike representation of reality, *because we do not see all grounds at the same time*, all clear at the same time, but we look at the pencil, then at the background, then back to the pencil, so to speak.

If you add to this what you already know about contrast and tone, reinforcing both effects a little in the objects closer to you and diminishing them in what is immediately behind them, then you will achieve the illusion of depth that you must capture in order for your works to win admiration, whether your subjects offer a lot of atmosphere or only a little.

Figs. 196 and 197. To represent depth in objects that are all in the foreground (such as in a still life, a figure drawing, or a portrait), the artist can define the nearest forms more clearly, leaving those farther away out of focus. This technique imitates the way our vision works: When we are looking at something near to us, our eyes do not clearly define the objects behind it.

196

197

Light and Atmosphere Are Everywhere

Atmosphere is Everywhere

In front of and behind the model, to one side and the other, there is atmosphere, there is air. For this reason, the artist "draws air" everywhere. Many beginners draw or paint well, *too* well. They carefully outline profiles, define forms with extraordinary sharpness—with the tip of a number 2 sable brush or with a finely sharpened lead pencil. And they have a fit when the pencil or brush goes over the edge of a shaded area, and hurriedly take their brush or eraser to it, working and working on the outline until everything is completely dry, stiff, overdone. Such beginners are not artists and do not know what painting with air and painting air means.

No, objects are not rigid, fine and sharp as a mold for shaping precisely measured pieces. Objects are alive, because they possess color and reflect light, and light vibrates. And our gaze is not static or fixed in one direction.

The Illusion of Space Is Rendered by Blending Contours

But we are talking here about *all contours*, including those within the frame of the model, like a flower which, though forming part of a bunch, still has its own contours, or like the arm which has the body as its background.

However, I do not mean that we should blend until everything loses consistency. Michelangelo, when asked how he created such beautiful statues, answered ironically: "Do you see that stone? Inside it there is a statue: all you have to do is break off little pieces until it appears; but you have to know your trade so as not to take off so much that you can no longer see it, for the danger lies as much in taking off too little as in taking off too much."

Figs. 198 and 199. Portraits of Bertrand Russell drawn by an inexperienced beginner and a professional artist. In the first, the likeness is acceptable, almost perfect, but technique and mastery of the art are lacking. There is no air, no atmosphere, no artistic vision in the clearly defined, hard features and contours. These aspects are present in the second version.

198

199

200

Fig. 200. J.M.W. Turner, *Musical Evening*. Tate Gallery, London.
Sketches often provide good examples of representing the third dimension, of interposed atmosphere, as is shown in this sketch by Turner. He anticipated the Impressionists in his loose, spontaneous style.

As the finishing touch to all you have seen and read, and learned up to this point, we are now going to paint two pictures: a still life in valuist style, in which we will highlight contrast by using side lighting, which accentuates volume, and a portrait in colorist style, with front lighting, practically flat colors with hardly any shade. And I said "we are going to paint" because the ideal would be for you also to paint two or more pictures, practicing particular directions and qualities of light, contrast and atmosphere accentuated to a greater or lesser extent, and so on. This would be a fine way to round off the teachings of this book on light and shade in drawing and painting.

201

Light and Shade
in Practice

José M. Parramón Paints a Still Life Using Valuist Techniques

202

203

Figs. 202 and 203. The artist José M. Parramón, author of this book, is about to do two paintings for us. Here is the model for the first painting, in artificial lighting for maximum contrast.

204

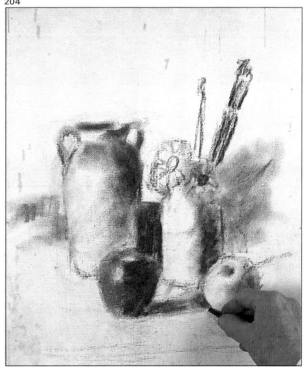

In Figure 203 on this page, you can see my model. I am using artificial side lighting with a direct light to create and accentuate shadows and contrast. I will paint this in valuist style, which will bring out its volume.

I begin by doing a quick drawing in charcoal in which I indicate shadows right from the start, but just placing them, framing and proportioning elements in the picture. I do not draw the forms of the creases in the background, for this is not necessary. I will paint them in directly with my brush (Fig. 204).

Next, following Jean-Baptiste-Camille Corot's rule that "You have to begin a painting with the volume, by painting the shadows," I quickly paint the areas in shadow, in their approximate colors, but without adjusting them as yet. And I fill the basic forms of the model with color: the jars, the apples, the white cloth in the background, now sketching in the creases (Figs. 205 and 206).

With my picture now stained, I begin to paint over it, adjusting colors and shadows. The yellow of the smaller jar is fine for the moment, but the earthenware jar needs a lighter, more earthy color.

205

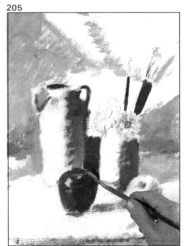

206

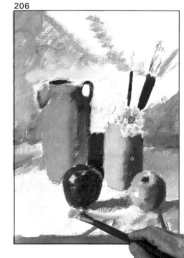

Second Stage: Determining Values and Contrasts

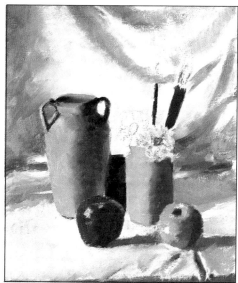

207

Figs. 207 to 210. At the end of this second stage, the painting is practically finished; all there is to do is to correct a few tones, complete a number of the forms and colors, and highlight contrasts.

208

209

210

You can see the result of the adjustments I made at the end of the first stage in Figure 207. The color of the yellow jar is the same as before, while that of the earthenware jar has been completely corrected, and I have constructed the rim and the handles, including the shadow cast by one of them. The apples are the same, and the cloth has only been sketched into my picture, while the daisies are still white and the paintbrushes exist only in roughly sketched form. From this point on, changes will be significant, though not too radical: I paint and correct the color and form of the yellow jar, softening the yellow, correcting the contours, giving it "air"—that is to say, diluting it—and I begin to paint the petals of the daisies (Fig. 208). Next I work on the green apple, rectifying the color, painting out the highlight I had given it, constructing lights and shades, using a reddish color (Fig. 209).

I complete this second stage by constructing the brushes, painting the highlights of the apples, adjusting once more the color and tonality of the earthenware jar, and finally adjusting the form of the background on the left-hand side, provoking a contrast next to the light tone of the earthenware jar (Fig. 210).

Third Stage: The Final Details

If you compare the finished version (reproduced in Fig. 215 on the following page) with the version as it stands at the end of the second stage (Fig. 210 on the previous page), you will see that the differences between the two center chiefly on the construction and finish of the daisies, a process illustrated in Figures 211, 212, and 213 on this page. I have also corrected the form in the left-hand side of the background, making the upper section lighter, softening the gradation, but of course conserving the provoked contrast at the limit of the lighted area of the earthenware jar. Finally, I have finished the paintbrushes and added a number of reflected lights on the jars and the green apple.

There are also tiny, almost imperceptible details that have been added to finish the picture: For example, look closely at the provoked contrasts behind the petals of the daisies in the background (Fig. 211), without which the white of the petals would not stand out. In this final stage I constantly diluted tones, softened contours and profiles, sometimes provoking lack of definition. Why? To represent space, atmosphere, the third dimension within a picture containing contrasts, in the valuist style.

Figs. 211 to 215. Here I am refining the forms of the daisies, provoking contrasts in order to highlight the white of the petals. Next I apply the highlights on the ferrules of the brushes, reinforce some of the reflected lights, rectify forms and colors in the background cloth and the tablecloth, and so on. These finishing touches do not change the essentials of what has been painted previously.

Fourth and Final Stage: The Finished Picture

215

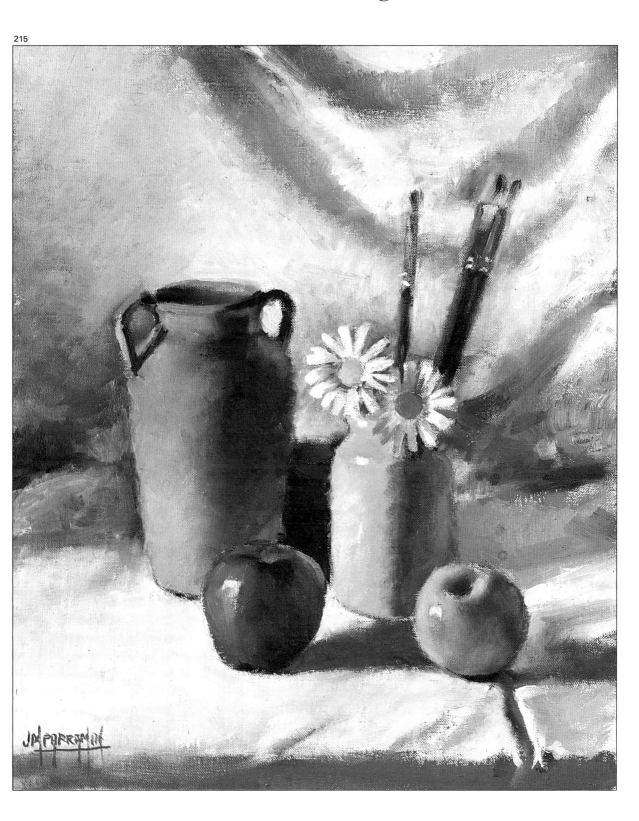

Painting a Portrait in the Style of the Colorists

216

217

Figs. 216 and 217. Here is the model with front lighting, almost without shadow. Within the charcoal drawing you can see the outline of the canon for the human head.

218

219

220

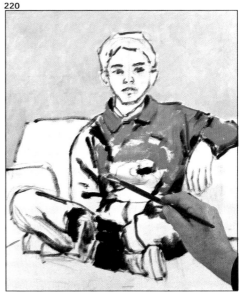

Figs. 218 to 220. First I fixed the drawing, then painted the background a bright yellow and drew the model with brown oil paint. Next I stained the sweatsuit with green mixed with ochre, a tone harmonious with the color of the background.

I am not exaggerating when I say that I spent a good hour trying out and studying the pose of my model, contemplating and looking, imagining how this portrait of a child could really turn out to be *the portrait of a child*, and not that of an adult. I wanted my picture to be cheerful, happy, formal, and *colorist*. In this preliminary study, before beginning to draw or paint, I decided to lower the back of the sofa so that the model's head would be directly against the background, and I chose a yellow background. I did not, at this stage, decide on the color black for the sofa, but did have the thought of darkening its color in order to highlight the figure of my model.

Second Stage: Overall Staining in Flat Colors

221

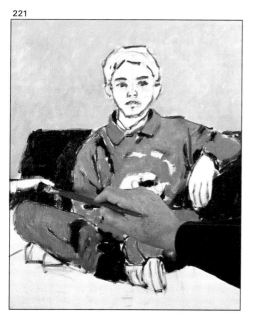

222

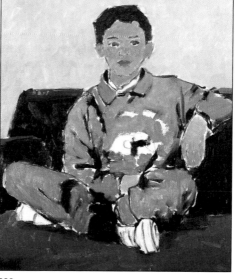

Figs. 221 to 223. Fill in spaces, stain surfaces, eliminate the white of the canvas—this is the first task to be done to avoid mistakes involving colors and contrasts. At the end of this stage (Fig. 223), changes made in accordance with a personal interpretation of form and color can be seen: the ochre tendency of the green of the sweatsuit, the yellow background, the lowering of the back of the sofa to highlight the head against the light background, and the black color of the sofa to give greater definition to the form of the model.

223

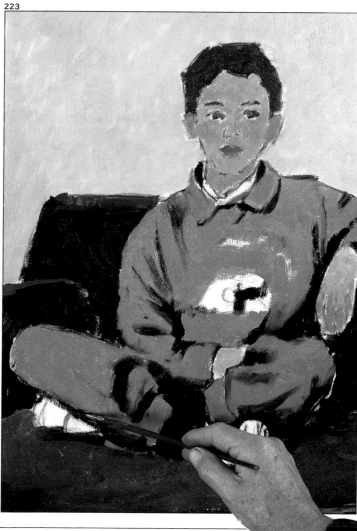

And with these initial ideas, I began to draw, in charcoal, framing the proportions of the head using the formula of the canon for the human figure, structuring the figure with a loose style, linear. I fixed the drawing and began to paint.

(The text below is a transcription of the notes I made on my cassette recorder while I worked.)

"I paint the background yellow and go over the figure of the model with a mixture of dark umber and Prussian blue with a little red. The child's green sweatsuit I paint with an emerald green mixed with cadmium yellow, ochre, a little Prussian blue and, again, a touch of red. I alternate this green with a black composed of emerald green, Prussian blue, and carmine. Then, I think, the sofa could be painted black. Black, green, yellow. I try it out, and yes, it works. I finish staining by painting the face with a slightly darkened flesh color. Then I paint the hand and add some finishing touches to the sweatsuit, thickening the color. This stage is completed." (See Fig. 223.)

Third Stage: The Face and Hand

"For the features of the face, I use sable round brushes. I place the eyebrows and eyes, drawing and painting without the reference point provided by the original drawing, which can no longer be seen. Now I paint the ears and the mouth. This right eye . . . I'm going to lower it; it's too high. And the overall color is too bright (Fig. 227). I'll come back to it tomorrow."

"Now I'm working hard on the face, repainting forms and colors. This second session lasts two hours. I look at the picture in the mirror. It isn't right. The left eye (the right one for us) is out of place, the mouth is too small, the ears should be higher up, the forehead and hairline are wrong, and the neck is too narrow. I'll stop now."

It was four days before I went back to my portrait, working on it again without the model, using a photograph. And why not? There is no reason to disdain the help of a photo. Edgar Degas knew this, Salvador Dalí did not hesitate to paint from photographs, and many artists use them today. I reconstructed most of the face, losing a little of the colorist style perhaps, but achieving greater likeness. And, after two hours of intensive work, I finished. Oh, I was forgetting! I finally changed the tone of the background, leaving it the same light color with a yellow tendency, but giving it more a broken, dirty tone. In the face, I added a few green reflections, also putting in a number of red reflections to the sweatsuit. I let another two days pass by, looked at my picture again in the mirror, and signed it.

224

225

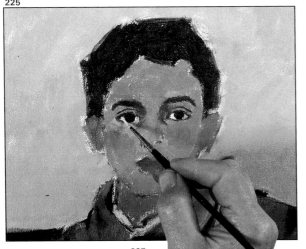

226

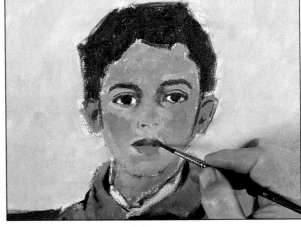

227

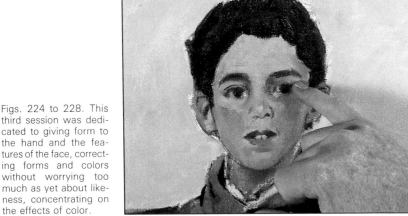

228

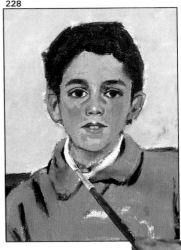

Figs. 224 to 228. This third session was dedicated to giving form to the hand and the features of the face, correcting forms and colors without worrying too much as yet about likeness, concentrating on the effects of color.

Fourth and Final Stage: Adjusting the Face and Background

229

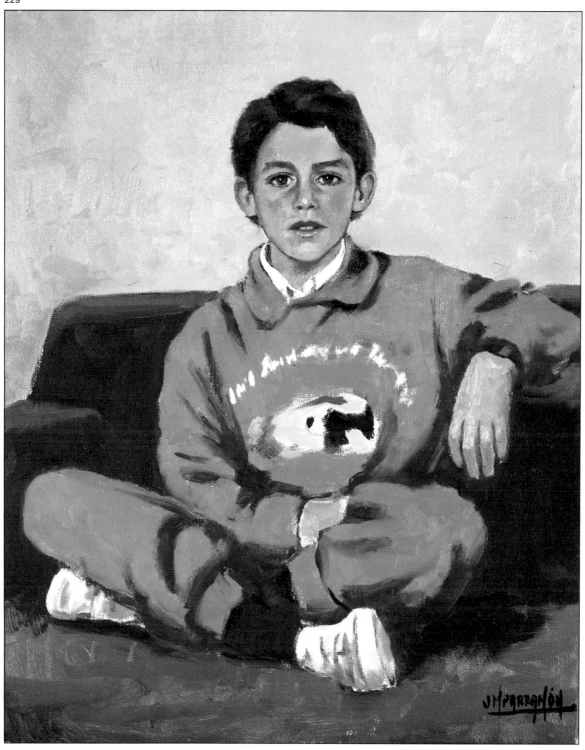

Fig. 299. At the end of the final session, after four days without looking at the picture, I decided that the yellow was too intense, and the position and form of some of the features of the head needed changing. I therefore corrected the form of the forehead and hairline, brought the ears a little higher, and perfected the situation of the eyes, the mouth, and jaws. Finally, I adjusted the form of the collar of the shirt and the sweatsuit in general.

Acknowledgments

The author acknowledges the artistic cooperation of Miquel Ferrón, and the firm Piera, for their assistance in drawing and painting materials and data.